SEARCH FOR THE
BLUE GOOSE

Bayeux Arts
INCORPORATED

in collaboration with

THE ARCTIC INSTITUTE OF NORTH AMERICA

Search For The Blue Goose
J. Dewey Soper — The Arctic Adventures of a Canadian Naturalist
Text : Constance Martin / Watercolour paintings : J. Dewey Soper
© Copyright 1995 by Bayeux Arts Incorporated and
the Arctic Institute of North America

Published by :

Bayeux Arts Incorporated
119 Stratton Crescent S.W., Calgary AB, Canada T3H 1T7

P.O. Box 586
1 Holway Point, Machias, Maine 04654, U.S.A.

Spantech House
Lagham Road, South Godstone, Surrey RH9 8HB, U.K.

Cover Painting : J. Dewey Soper
Design : George Allen
Production Assistance : Christine Spindler, Lyn Turnbull
Artwork Photography : Jim Tinios
Printed in Hong Kong by King's Time Industries

Canadian Cataloguing in Publication Data

Martin, Constance
Search for the blue goose

ISBN 1-896209-14-9
1. Soper, J. Dewey (Joseph Dewey), 1893 – 1982.
2. Naturalists — Canada — Biography. 3. Blue goose — Canada.
4. Baffin Island (N.W.T.) – Pictorial works. 5. Canada, Northern — Pictorial works.
6. Natural history — Canada, Northern — Pictorial works.
I. Soper, J. Dewey (Joseph Dewey), 1893 – 1982. II. Title.
QH31.S66M37 1995 508.719'092 C95-910088-1

Acknowledgements

I thank the following for their encouragement and help in writing this book:
The Arctic Institute of North America, the University of Alberta Archives for permission to reproduce Saila of Nuwata's map of Foxe Land,
Ray Alisauckas of the University of Saskatchewan, who provided important references and insight about the blue goose,
Eric Tull, Arctic librarian at the University of Calgary, and Roland Soper and his family for making the project possible
through their generous bequest of J. Dewey Soper's watercolours to the Arctic Institute. *Constance Martin*

The publishers gratefully acknowledge the generous support and assistance of
THE CANADA COUNCIL and THE ALBERTA FOUNDATION FOR THE ARTS
Committed to the Development of Culture and the Arts.

SEARCH FOR THE
BLUE GOOSE

J. DEWEY SOPER — THE ARCTIC ADVENTURES OF A CANADIAN NATURALIST

TEXT BY CONSTANCE MARTIN

PAINTINGS & ILLUSTRATIONS BY J. DEWEY SOPER

Contents

Dedicated to Damien, Anna and Alexandra

P r e f a c e

J. Dewey Soper was a true northern scientist in the Renaissance man tradition. Between 1923 and 1931 he travelled extensively in the eastern high Arctic, capturing a landscape, its colours, its culture, and a unique artistic aesthetic in the process. More than a southern scientist in the North, Dewey Soper became an accomplished traveller on the land, eating country food and carefully learning the Inuit way. Whereas others went north for a summer's research, Soper often overwintered. He developed a keen eye for both the natural world and Inuit social/ecosystem relationships within it; he was amongst the first in his scientific community to understand the elaborate Inuit systems of seasonality and scheduling of the harvest.

Today Dewey Soper's oeuvre of watercolours (some 200 pictures) is beneficially held and maintained by the Arctic Institute of North America at the University of Calgary. These pictures carefully portray ethnographic details of day-to-day life, the changing colours of the Arctic landscape, its flora and fauna, and the joy of both winter and summer travel on ice and tundra. Soper's Inuit friends are invariably on the move, happy and competent in a landscape that still frightens those who have not experienced it. He does not paint a wilderness - he paints a homeland. Soper's own multidisciplinary competence shines through in these pictures depicting the search for the blue goose. They are without equal in their time and preserve images of life on the land that predates the now pervasive mixed economy lifestyle of high Arctic settlements.

Dewey Soper painted these pictures in his retirement in Edmonton, sometimes from photographs and sometimes from memory. They were his last project in a life extremely well lived. I hope they will demystify some aspects of northern life for southern readers, and encourage northern readers to continue their efforts to preserve traditional environmental knowledge in a changing society.

Dewey Soper's enduring legacy is a gift to all Canadians and a vivid reminder of our northern heritage. We are indeed lucky that Constance Martin has prepared this text; together with Dewey Soper's pictures it captures a small piece of the Arctic soul.

Michael Robinson,
Executive Director, Arctic Institute of North America *April, 1995*

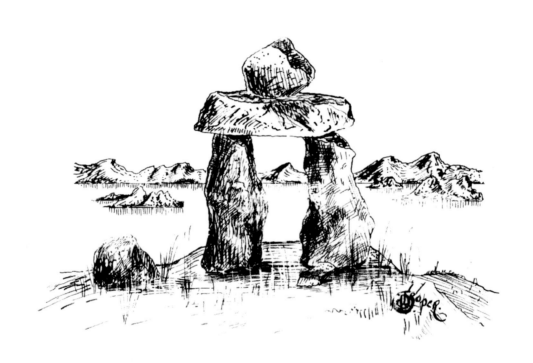

Part 1 — 1923

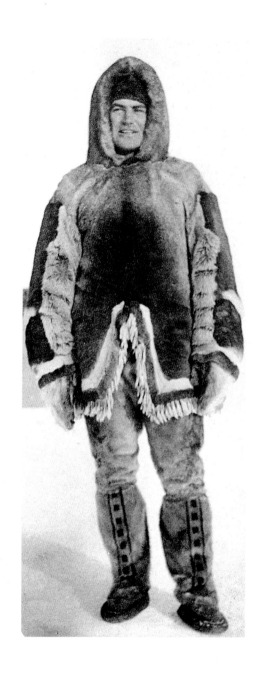

J. DEWEY SOPER — WINTER OF 1924–25

"*I may say that my interests turned more and more northwards early in life. I seem to have been born with this longing for boreal latitudes. The more I read, the stronger was this youthful desire to get to the land of the Eskimo where many famous explorers such as Franklin, Nansen, Amundsen, Sverdrup, Peary and others had made their mark.*" — J. Dewey Soper

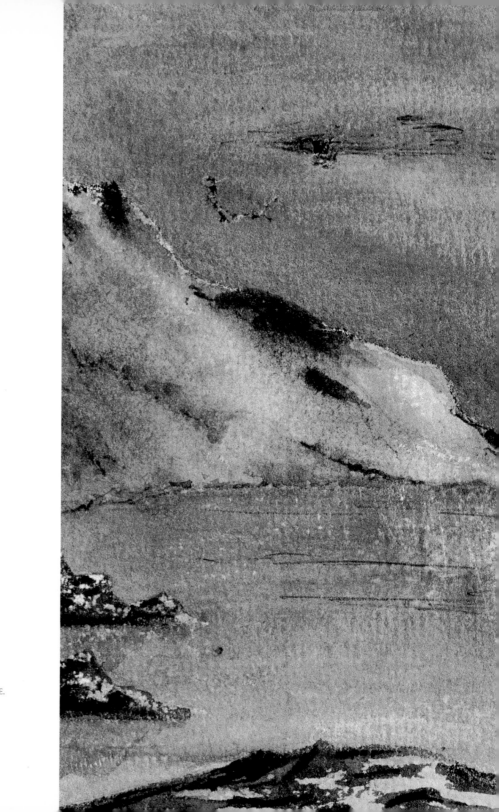

LATE SUNSET IN PANGNIRTUNG FIORD, BAFFIN ISLAND, LOOKING
SOUTHWARD FROM THE R.C.M.P. POST AT PANGNIRTUNG VILLAGE.

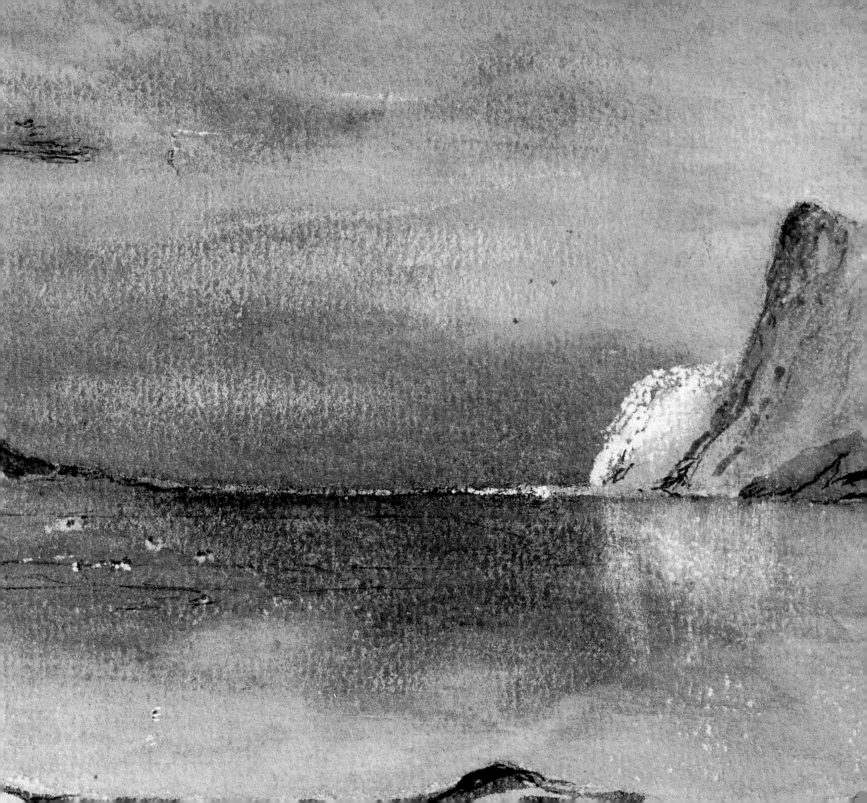

As he grew in years, J. Dewey Soper's fascination with the North grew as well. The many beautiful books on Arctic exploration available during his youth set his curiosity on fire. These were books filled with haunting tales of impossible obstacles in the frigid cold. Their pages also held spellbinding pictures of soaring icebergs, magical skies of brilliant reds and oranges, as well as images of profound and forbidding desolation.

There were books telling stories of the Vikings, the early Arctic voyagers who sailed to Iceland, Greenland, and Ellesmere Island. There were the chronicles of Europe's search, spread over four hundred years, for polar routes that would lead to the fabled riches of the Orient. But the period during which Arctic exploration became a truly popular literary theme began after the Napoleonic Wars of the early nineteenth century when Britain renewed her search for the so-called Northwest Passage.

By mid-nineteenth century, intense public passion had been aroused by the mysterious disappearance of the Franklin Expedition in 1845. Governments and private citizens joined in a relentless search for Sir John Franklin and his crew of one hundred and thirty men. Newspapers and magazines kept the story burning before the eyes of the Western world. Each returning voyage recorded its exploits in a handsomely published journal narrating the expedition's thrilling adventures and illustrated with pictures of the frozen north "wrapped in a white shroud".

All these readings proved a powerful spur to the imagination of young naturalists like J. Dewey Soper. When the opportunity came for him to search for the blue goose — the mystery of whose habitat had baffled scientists for years — it was as if the doors had opened to a world Soper had dreamed of most of his life.

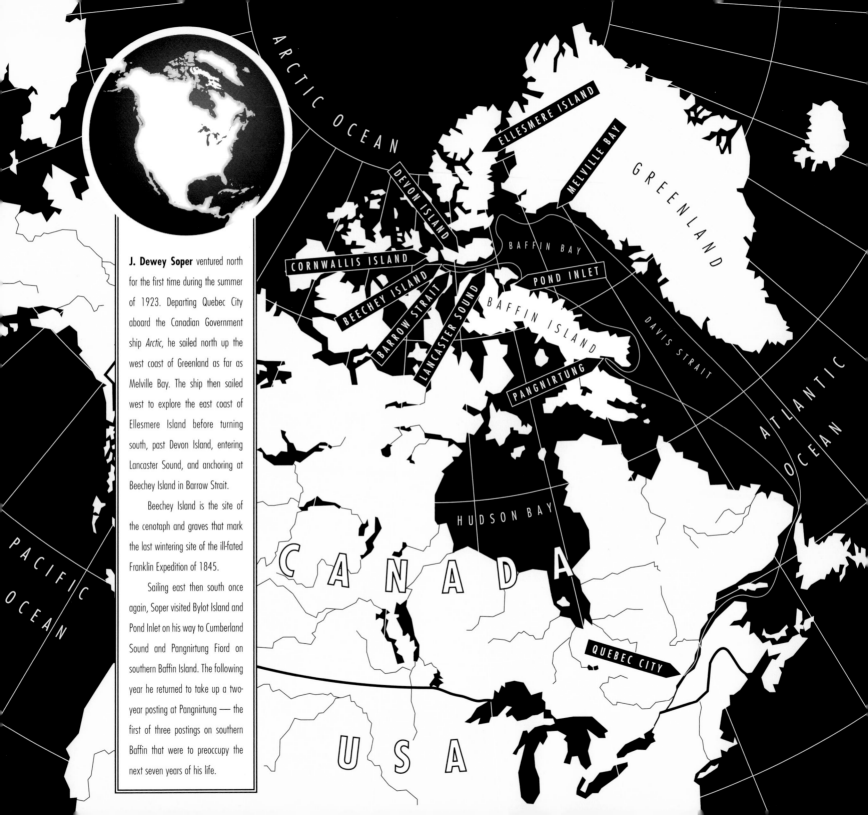

J. Dewey Soper ventured north for the first time during the summer of 1923. Departing Quebec City aboard the Canadian Government ship *Arctic*, he sailed north up the west coast of Greenland as far as Melville Bay. The ship then sailed west to explore the east coast of Ellesmere Island before turning south, past Devon Island, entering Lancaster Sound, and anchoring at Beechey Island in Barrow Strait.

Beechey Island is the site of the cenotaph and graves that mark the last wintering site of the ill-fated Franklin Expedition of 1845.

Sailing east then south once again, Soper visited Bylot Island and Pond Inlet on his way to Cumberland Sound and Pangnirtung Fiord on southern Baffin Island. The following year he returned to take up a two-year posting at Pangnirtung — the first of three postings on southern Baffin that were to preoccupy the next seven years of his life.

ARCTIC OCEAN

ELLESMERE ISLAND

MELVILLE BAY

GREENLAND

DEVON ISLAND

CORNWALLIS ISLAND

BAFFIN BAY

BEECHEY ISLAND

POND INLET

BARROW STRAIT

LANCASTER SOUND

BAFFIN ISLAND

DAVIS STRAIT

PANGNIRTUNG

ATLANTIC OCEAN

HUDSON BAY

C A N A D A

PACIFIC OCEAN

QUEBEC CITY

U S A

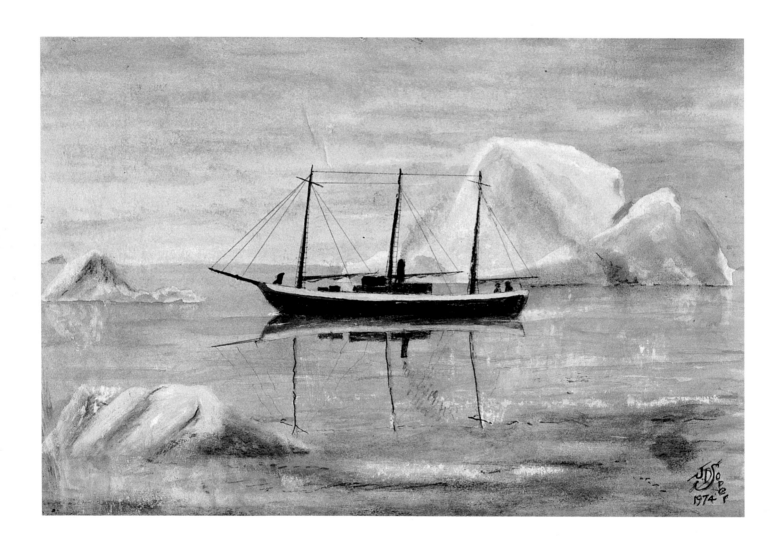

THE STEAMER C.G.S. *Arctic* PASSING AN ICEBERG IN BAFFIN BAY.

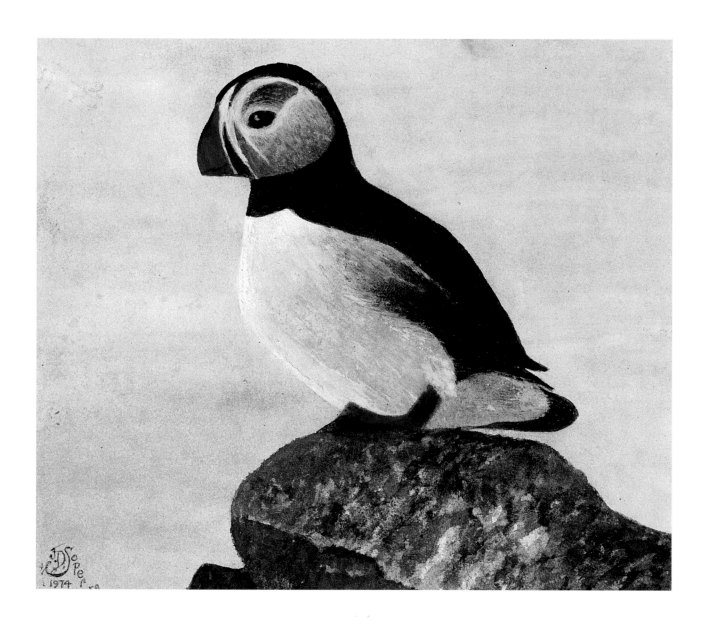

THE COMMON PUFFIN, WHICH NESTS IN SUMMER ALONG ARCTIC LABRADOR, HAS BEEN REPORTED AS FAR NORTH AS CORNWALLIS ISLAND.

Some of the most spectacular Arctic discoveries did not take place until early in the twentieth century. It was only in 1905 that Roald Amundsen's *Goja* was able to sail through a Northwest Passage. Robert E. Peary raised a flag at the North Pole in 1911. And, to this day, the disappearance of the Franklin Expedition remains a baffling mystery. Clearly, there was much to be discovered, vast spaces to be explored. There always is.

Soper read a lot, and dreamed a lot. It was easy to dream as one read Fridtjof Nansen's poetic *In Northern Mists*, glowing with the imagery of the Arctic covered in a spotless mantle of ice, a "mighty giant" stilled by a profound sleep of death until awakened by the dawn of history and the lure of adventure.

Other explorers of the time, like Stefansson and Sverdrup, wrote of the pervasive and harsh emptiness of the northern regions. Their childhood wanderings, much like Soper's, had taken them across rugged northern country in every kind of weather. Their travels and adventures had instilled in them not only a love of the pristine wilderness and its wildlife, but had also trained them to survive, when necessary, as solitary individualists.

One of the books Soper admired a great deal was Sir John Richardson's *Journal of a Boat-Voyage Through Rupert's Land and the Arctic Sea*. Although a chronicle of an expedition from 1851, the book was republished during Soper's youth. It contained a large section on the physical geography of North America and was lavishly illustrated with wildlife.

Books shaped Soper's imagination, and his early life in the farm country of southwestern Ontario near Guelph sharpened his yearning for a knowledge of wildlife. He never tired of wanting to know more and more about the natural world, birds in particular. This need to know became, in his own words, a "divine excitement in the blood".

Soper was also influenced by Charles Francis Hall's *My Life Among the Esquimaux*. Hall was an American explorer who had gone to the Arctic to search for the missing Franklin expedition. He was a practical man who realized that the best way to survive in the northern regions was to learn to live like the people who had made it their home. Hall was one of the first to recognize the Eskimo people's (also known as the Inuit) extraordinary self-reliance, their ingenious hunting techniques, and their skills with dog-sledding and the construction of igloos.

Soper's fascination with tales of exploration became even more intense as he came across exciting images illustrating the many Arctic journals of his time. Ever since James Cook sailed to the South Pacific, expeditions were required to follow strict rules for recording their observations in the New World. As a result, ships often sailed with

their own artists and natural scientists. The journals would follow soon after their return home. It was part of Soper's genius that he was able to combine the two roles — that of artist and scientist — into one.

Soper realized in his late twenties that he could not enter a professional field in the natural sciences without formal training. He worked hard as a builder and, with the money earned as wages, he studied at the University of Alberta. His chance to go north came soon afterwards.

R.M. Anderson, a friend of Soper's, was a leading natural scientist with the National Museum of Canada. During the summer of 1923, Anderson invited Soper to join a government patrol voyage to the Arctic. His task was to collect wildlife specimens for the museum's collection. In preparation of his role as a natural scientist for the museum, Soper reread Darwin's *Voyage of the Beagle*.

Accompanied by members of the R.C.M.P. and employees of the Hudson's Bay Company, Soper boarded C.G.S. *Arctic* in Quebec City. Sailing up the west coast of Greenland, they reached Melville Bay. The bay was a treacherous place where massive icebergs gathered, and was known as a graveyard for ships travelling north. It was also a backdrop for ice-crystal palaces of breathtaking beauty. Here Soper came face to face with his first truly Arctic landscape.

The voyage continued up the east coast of Ellesmere Island to within 11 degrees of the North Pole. Much to his surprise, Soper found flowers here — poppies and mountain avens in bloom. Unfortunately, unable to push through the ice any further, the *Arctic* was forced to turn south. On this journey, the ship entered Lancaster Sound and anchored at Beechey Island on Barrow Strait.

Beechey is quite different from the more northern Ellesmere Island. It is barren, devoid of any birds or other wildlife. And yet, it was on nearby Resolute Island that the most northern sighting of the puffin has been recorded. Though lacking in vegetation, Beechey harbours the site of the most famous landmark in the Arctic regions. It was here that Franklin and his crew wintered their first year in the North. Three of the seamen lost their lives here, perhaps a prophetic omen of the larger tragedy that lay ahead. Three graves and a memorial cenotaph are all that remain to remind us of the fate of the lost Franklin expedition of 1845.

The possibility of tragedy was never far away from the minds of explorers and arctic seafarers. But they tended to forget any dangers the moment they came face to face with the exquisite beauty of the polar regions. At unexpected

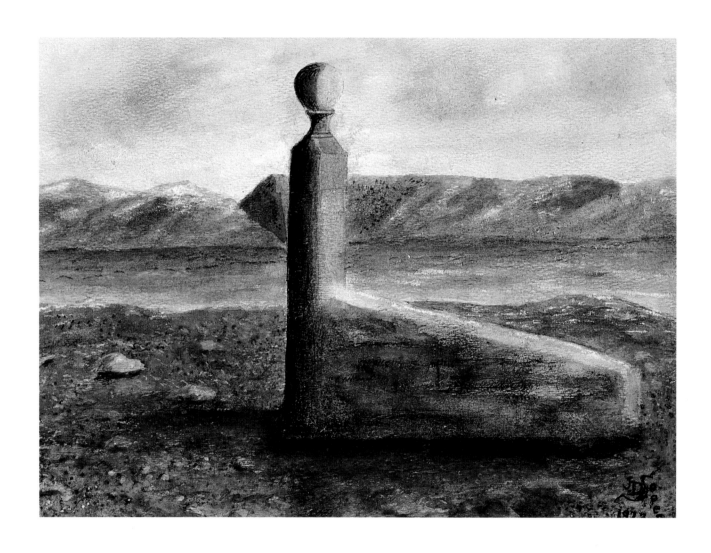

THE FRANKLIN CENOTAPH, BEECHEY ISLAND, OFF THE SOUTHWESTERN END OF DEVON ISLAND. AUGUST 17, 1923.

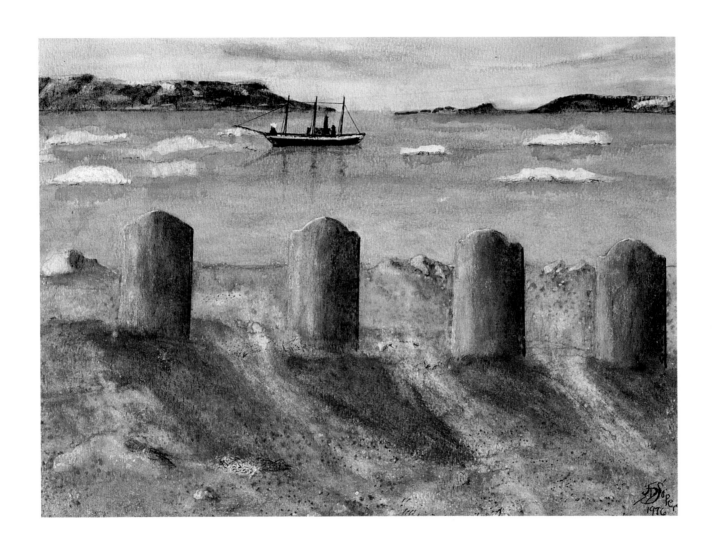

Oak headboards at Beechey Island, marking the graves of three seamen who died on the Franklin Expedition of 1845, and one who died on an 1854 search expedition.

moments, the glorious aurora borealis would turn the winter sky to brilliant colours. The refraction of light can sometimes create a mirage of fairy tale cities with majestic castle towers or, at other times, inverted images of ghostly ships suspended in space. Sometimes, a sudden ice-blink will make the line of horizon vanish, and the viewer will be lost in an infinity of empty space. Soper appears to have had his fill of such fascinating experiences on this voyage.

After it left the desolation of Beechey Island and turned south, the Canadian Government ship was fortunate enough to stop at other islands rich in bird life, mammals and plants. While gathering specimens on Bylot Island, Soper found time to observe Inuit paddling their canoes. At Pond Inlet, on northern Baffin Island, a beached narwhal was the focus of much excitement and speculation.

Later in the summer of 1923, while cruising along the eastern coast of Baffin Island, Soper passed some truly spectacular mountains which he later recorded among his illustrations. One of his most striking pictures is that of a massive iceberg, its brilliant whiteness set off against the vivid backdrop of a yellow and pink sky. Soper had encountered this wondrous sight that summer as his ship rounded the peninsula into Cumberland Sound.

After an eleven day visit to Pangnirtung Fiord on Cumberland Sound, Soper prepared to return to Ottawa. He carried with him over 166 specimens of carefully preserved birds, mammals, plants, marine invertebrates and Inuit artifacts for the museum. As is reflected in his illustrations, Soper probably spent hours on the deck of the C.G.S. *Arctic* during this return journey, thrilling to the mysteries he imagined dwelling beyond the ridges and peaks that loomed over the horizon.

But the quest that was to crown his illustrious career awaited Soper on his return to Ottawa. For his accomplishments during this first probationary mission he was rewarded with a two-year appointment to southern Baffin Island from 1924 to 1926. It was at this time that his naturalist friend, R.M. Anderson, introduced him to the work of the German ornithologist, Bernhard Hantzsch. Hantzsch was a brilliant scientist who died of trichinosis poisoning while attempting to cross the interior of Baffin Island in 1911. Fortunately, Hantzsch's Inuit companions had preserved not only his diaries and valuable bird notes, but also the record of his last harrowing trek.

Anderson realized the importance of Hantzsch's work on birds. In it, there were the German ornithologist's observations about the strange and elusive blue goose. It is possible that Anderson saw in Soper the ideal successor

to the German ornithologist's unfinished work. As for Soper, there is little doubt that he found in Bernhard Hantzsch the inspiration and challenge for his search for the blue goose.

The nesting grounds of the blue goose had remained a mystery for years. Today there are many nesting grounds, thanks to the spectacular increase in the goose population. In Soper's time, however, their rarity had driven generations of biologists to ponder over the birds' whereabouts on Baffin Island. But the 210,000 square miles of the island, one of the largest and virtually unexplored land masses in the Northern Hemisphere, had refused to give up the secret to the white man. As Soper has written: "Where in this vast area it nested was unknown. To hazard a guess . . . brought the truth no nearer."

CAPE DORSET — 1928 – 1929

Returning to the North in May of 1928, Soper took up residence at **Cape Dorset** on the south side of the Foxe Peninsula. It was here that Soper acquired the map that eventually led him to the nesting grounds of the Blue Goose at Bowman Bay. During this period, his explorations took him as far north as the Hantzsch River and to many points along the coast, including Nuwata, Bowdoin Harbour, Cape Dorchester and Cape Alberta, as well as to the interior of the Foxe Peninsula. His dedicated search for the Blue Goose nesting grounds ended in June of 1929 on the prairie of Bowman Bay at the Blue Goose River. Here, at last, he was able to witness and record the arrival, nesting and hatching of the elusive bird.

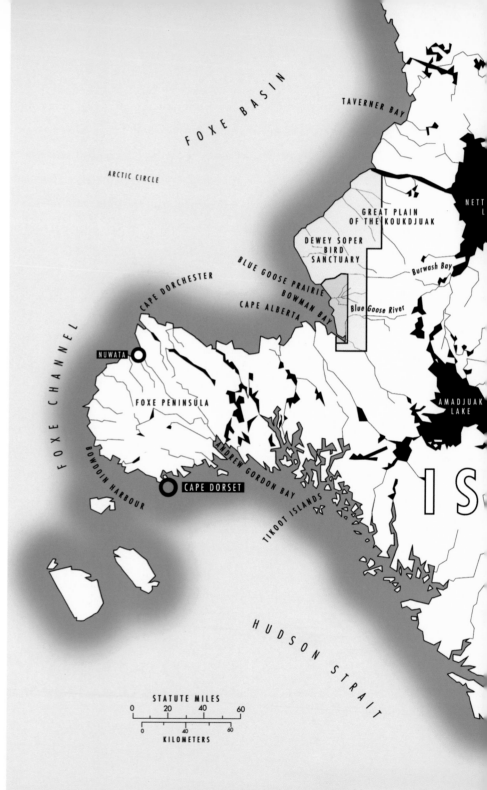

FOXE BASIN

TAVERNER BAY

ARCTIC CIRCLE

GREAT PLAIN OF THE KOUKDJUAK

NETT L

DEWEY SOPER BIRD SANCTUARY

Burwash Bay

BLUE GOOSE PRAIRIE

BOWMAN BAY

Blue Goose River

CAPE DORCHESTER

CAPE ALBERTA

FOXE CHANNEL

NUWATA

AMADJUAK LAKE

FOXE PENINSULA

Bowdoin Harbour

ANDREW GORDON BAY

IS

BOWDOIN HARBOUR

CAPE DORSET

TIKOOT ISLANDS

HUDSON STRAIT

STATUTE MILES
0 20 40 60

0 40 60
KILOMETERS

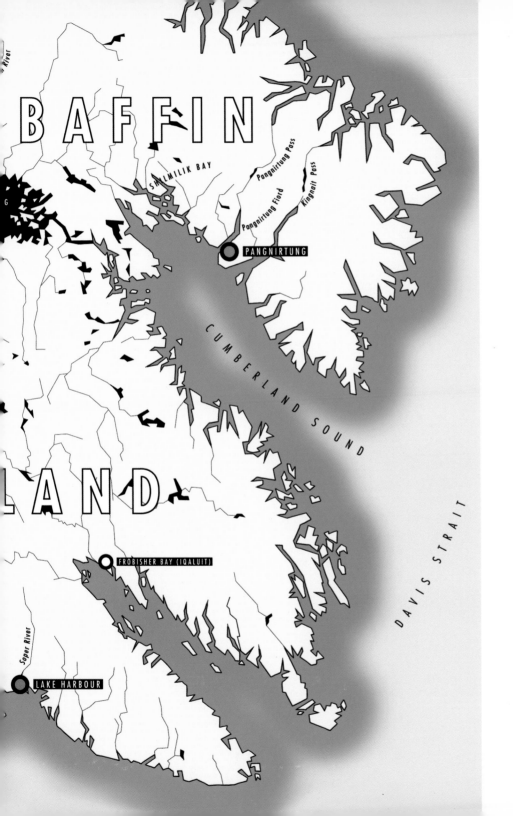

BAFFIN

LAND

SHILMILIK BAY

Pangnirtung Pass

Pangnirtung Fiord

Kingnait Pass

PANGNIRTUNG

CUMBERLAND SOUND

DAVIS STRAIT

FROBISHER BAY (IQALUIT)

Soper River

LAKE HARBOUR

PANGNIRTUNG — 1924 – 1926

Following his eleven-day visit of the previous year aboard the C.G.S. *Arctic*, Soper returned to Pangnirtung to live. **Pangnirtung** Post, on Cumberland Sound, served as Soper's home during his first extended assignment in the North. It was also the location of the R.C.M.P. post and the Hudson's Bay Company's operations. From their Pangnirtung base, Soper and his Inuit companions explored the fiords and coastal features of Cumberland Sound. They traversed Pangnirtung and Kingnait passes to the northeast and ventured to points far to the west, including Shilmilik Bay, 1882 site of a German scientific station, and on into Nettilling Lake in central Baffin Island.

LAKE HARBOUR — 1930 – 1931

The discovery of the blue goose nesting grounds proved to be the highlight of Soper's career. In appreciation of his work, the government offered Soper another one-year assignment at the R.C.M.P. post at **Lake Harbour** on the north side of the Hudson Strait. He was joined on this posting by his wife Carolyn and his two-year-old son Roland. Soper's task for the year was to explore along the coast from Lake Harbour and into the interior areas of the remote Meta Incognita Peninsula.

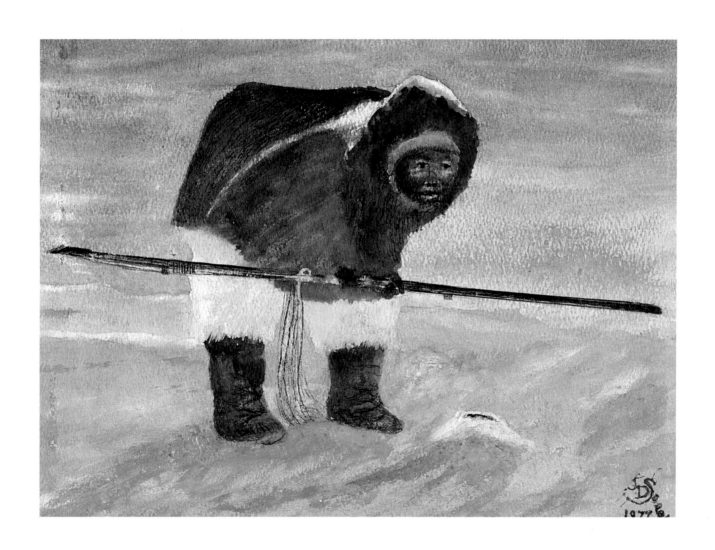

An Inuit hunter, standing motionless and alert, ready to harpoon a seal at its breathing hole (*agloo*).

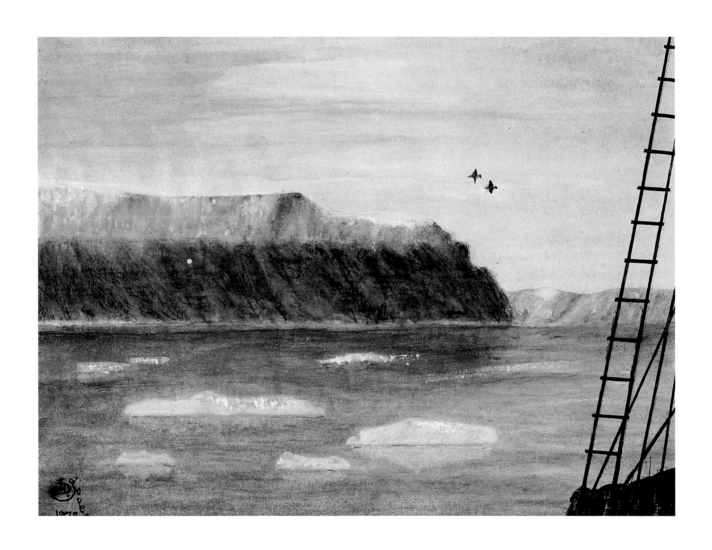

STRATHCONA SOUND, BAFFIN ISLAND, 1923.

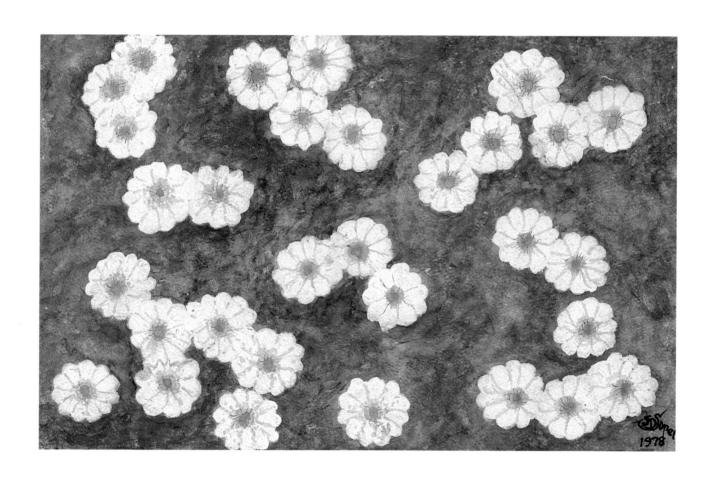

Mountain avens in mid-July on the Aswituk Ridge near Camp Kungovik.

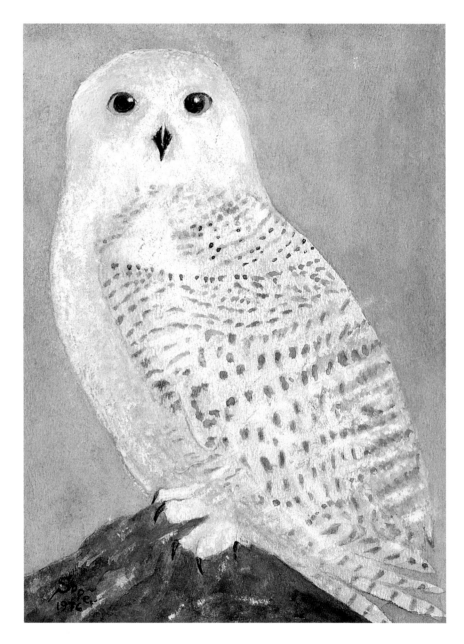

GREAT SNOWY OWL.

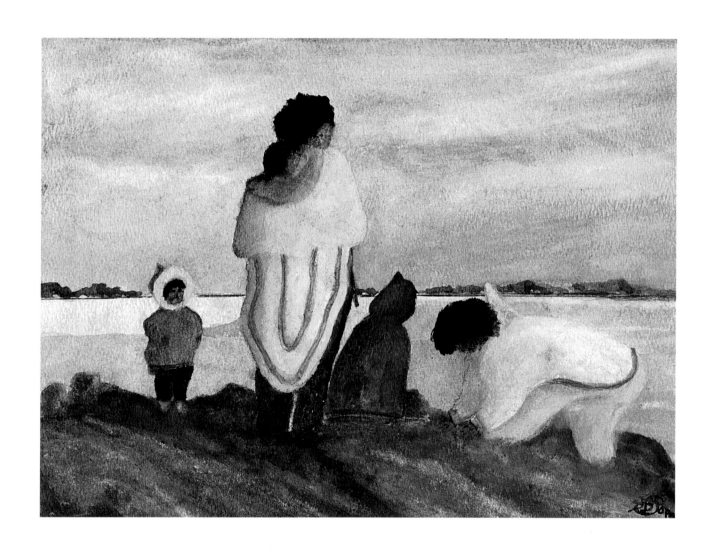

A GROUP OF INUIT ALONG THE COAST OF NUWATA, BAFFIN ISLAND, DURING THE SUMMER.

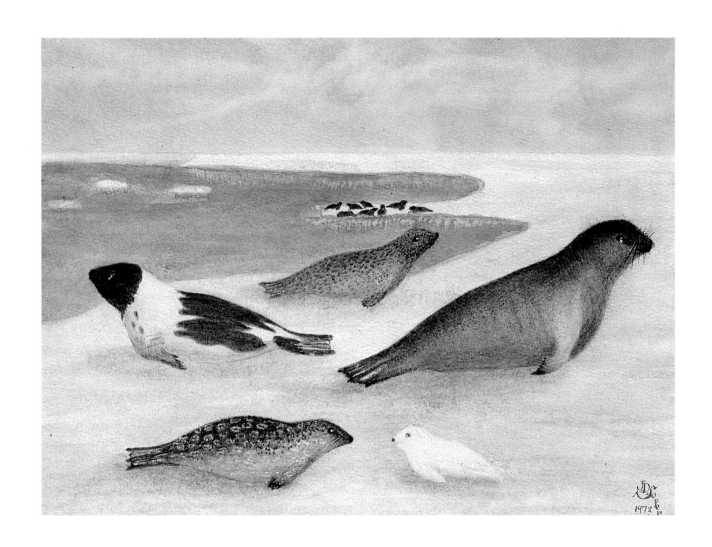

The Arctic's rich marine life included numerous seal species which Soper dutifully recorded here in a composite image.

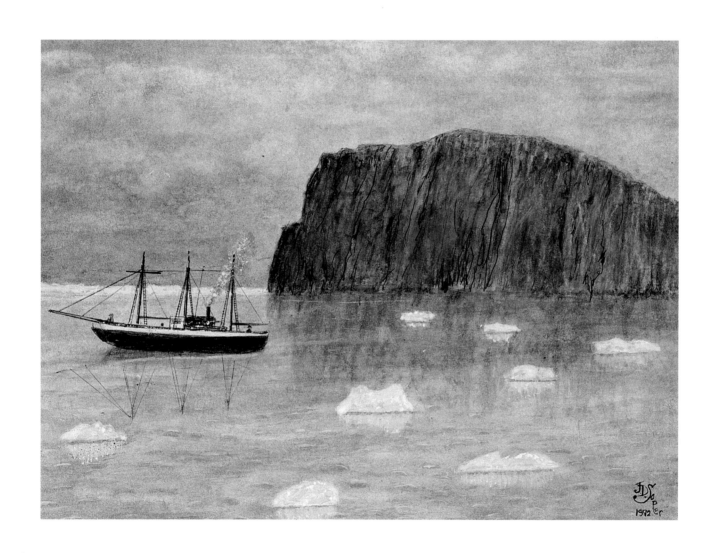

The C.G.S. *Arctic* passing a headland cliff, Devon Island, 1923.

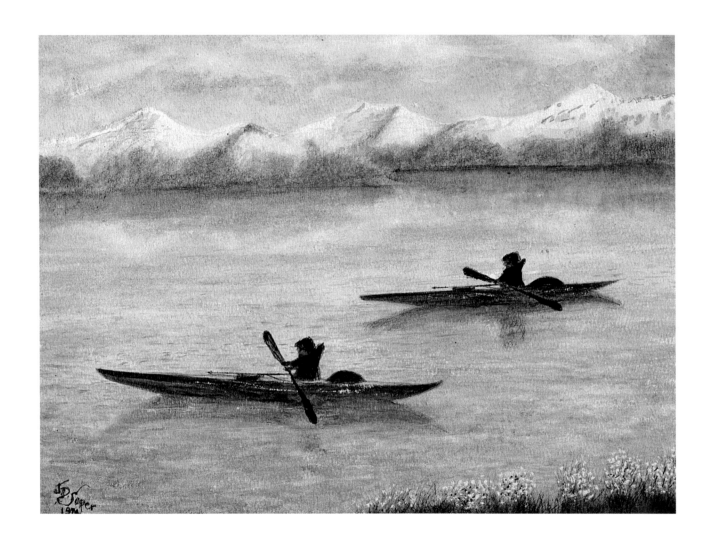

SEAL HUNTERS IN KAYAKS AT POND INLET.

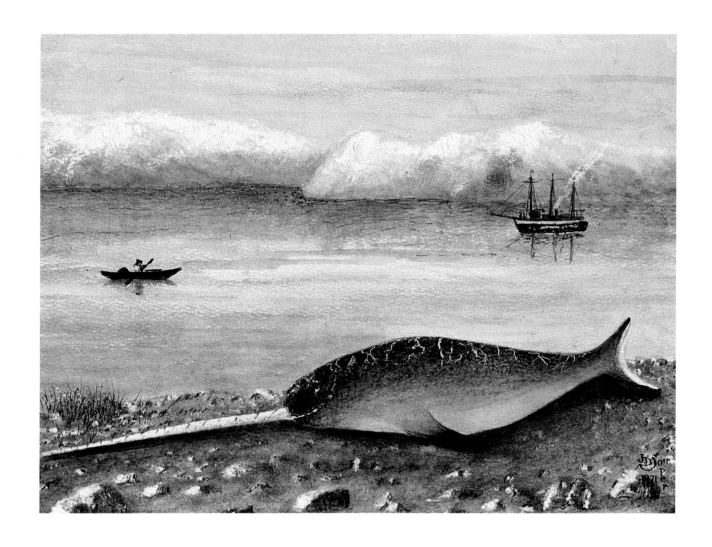

An adult narwhal, killed and beached by Eskimos at Pond Inlet. The C.G.S. *Arctic* lies anchored offshore. Bylot Island is in the distance.

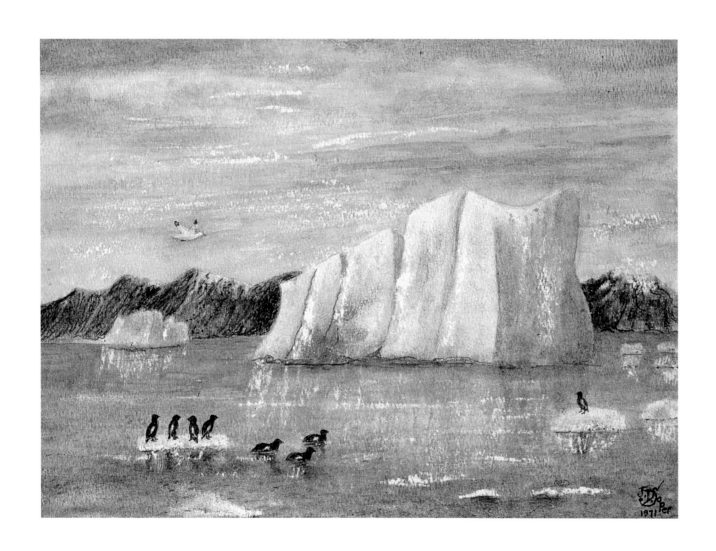

A huge iceberg lying at the entrance of Cumberland Sound, 1923.

Part 2 — 1924-1926

*P*angnirtung on Cumberland Sound, Soper's base for his two-year assignment, was not only an outpost for the Royal Canadian Mounted Police, it was also a centre of operations for the Hudson's Bay Company. Both these operations served a small Inuit village and the surrounding area. What was especially significant was that the Inuit had succeeded in preserving a unique way of life relatively unchanged over the centuries. Soper was exhilirated by his presence on Pangnirtung Fiord.

Soper drew delight from ordinary things, like the simple beauty of the sealskin *tupik* or tent. This shelter was still being made the way it probably had been for thousands of years. The use of duck canvas for tents was still relatively unknown. Other dwellings, always temporary, tended to use whatever materials could be found. Whereas the curing of skins for the sealskin *tupik* took time, the most efficient dwelling in these parts, the igloo, took the least. But the igloo's construction did demand considerable skill.

Of the various shelters Soper saw being used on Pangnirtung Fiord, none interested him as much as the igloo. It was a structure that best demonstrated the Inuit's brilliant survival skills. Large or small, the igloo's geodesic dome was simply the most appropriate shelter especially during the treacherous polar winter. It could be built in less than an hour by someone well-trained and experienced in the art. Inside, a seal oil fire could

AT RIGHT : DETACHMENT OF THE ROYAL CANADIAN MOUNTED POLICE AT PANGNIRTUNG, BAFFIN ISLAND, IN THE EARLY WINTER OF 1924. A WALL OF SNOW BLOCKS BUILT BY THE ESKIMOS HELPS TO PROTECT THE BUILDING FROM THE WIND AND COLD. THIS WAS THE HEADQUARTERS FOR SOPER FOR TWO YEARS WHILE EXPLORING, SURVEYING, AND COLLECTING SPECIMENS FOR THE NATIONAL MUSEUM OF CANADA.

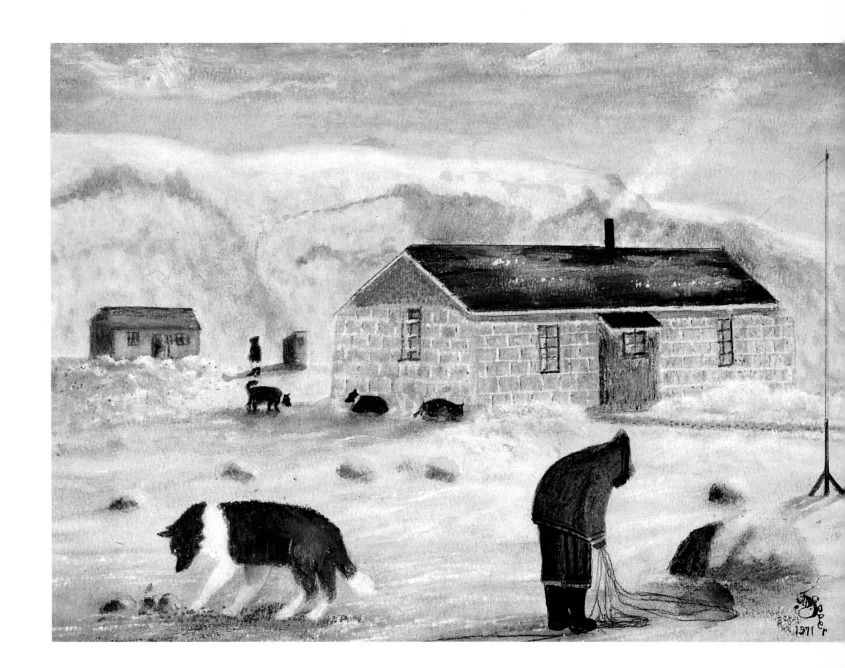

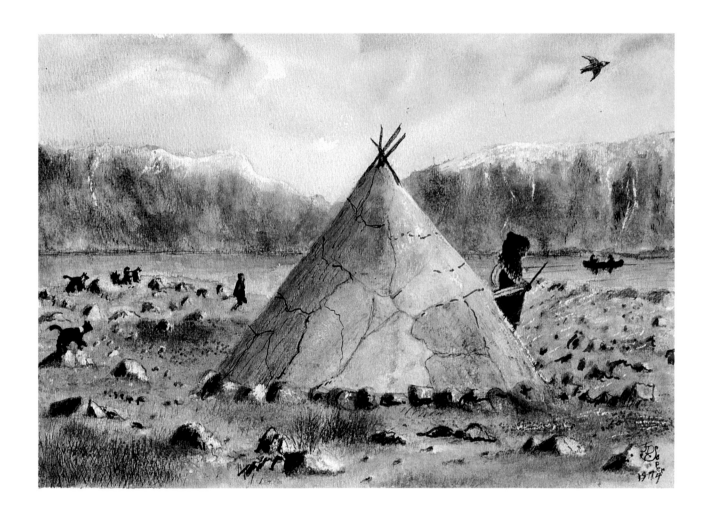

Inuit *tupik* (tent) at the Kuluk River, Pangnirtung.

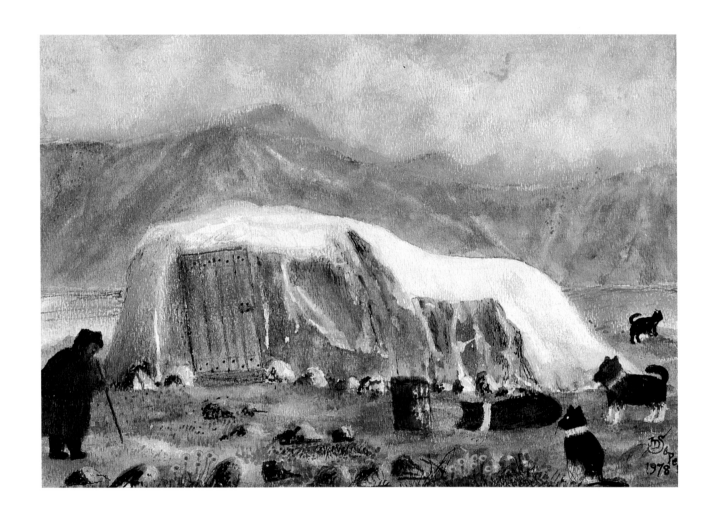

Inuit dwelling at Pangnirtung Fiord. Built of lumber and canvas, it was used year-round but banked with snow blocks in winter.

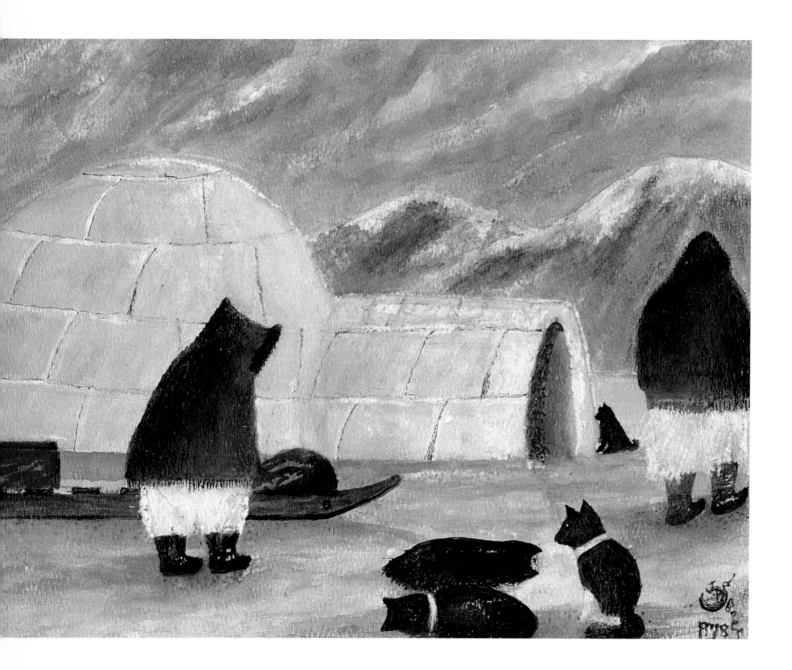

quickly provide warmth to a person clothed properly in caribou robes.

It was in Pangnirtung that Soper first befriended the Inuit and began to learn their skills and the rudiments of their language. He was a quick learner. This, together with his warm personality, brought him especially close to two individuals who proved to be most important to him during this period. One of them was Akatuga, a clever and experienced hunter whom Soper described as "the finest and most reliable of all the men I had ever known in the North". Soper accompanied him on many excursions, hunting animals, and gathering such rare specimens as a collared lemming.

The second person was Unga, Akatuga's wife. Among her countless other skills and qualities, Unga proved to be an excellent seamstress. With infinite patience and care, she prepared an entire wardrobe for Soper: outer and inner kuletaks (parkas), trousers, knee-high boots, and double mittens, long caribou socks, duffels, caribou skin ground robes and more. Soper loved his Arctic clothes and accessories and unabashedly captured all this finery in a self-portrait.

Soper's first summer on southern Baffin Island proved to be a veritable paradise of sunny days, blue skies, and sparkling waters. He recalls the days fondly in

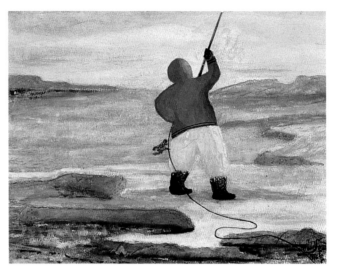

A HUNTER READY TO HARPOON A SEAL.

AT LEFT : INUIT AT A HEADQUARTERS IGLOO, CUMBERLAND SOUND.

A DWARF ARCTIC FIRE FLOWER, COMMON AT PANGNIRTUNG FIORD IN MID-JULY.

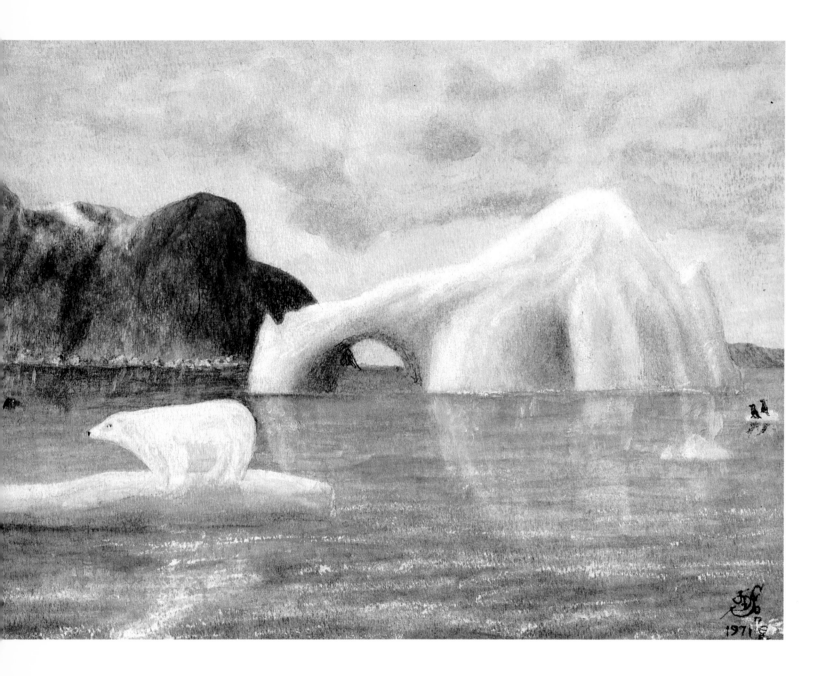

his diaries, perhaps with a certain nostalgia for time that was so fleeting and evanescent. It was a time to hear birds sing, time to watch the careless flight of bumble bees and butterflies amidst the exquisite bloom of Arctic flowers. These experiences provided him with a wealth of warm memories that were to sustain Soper during the long, cruel winter months that lay ahead.

Summer was also a time to explore the long coastline, many islands and deep fiords of Cumberland Sound. During the confinement of the arctic fall, Soper would find time to plan for the more arduous winter trips ahead. Soper would have to wait until after Christmas or the New Year for the sea ice to be thick or safe enough to support sledges, dogs or men. Until then, the snow would not be deep enough to build igloos. Only then could Soper begin the extended dog-team journeys into the unknown interior of Baffin Island in search of the elusive nesting grounds of the blue goose.

Soper filled the days of summer collecting specimens for the museum. True to his instincts as a natural scientist, he spent hours writing up the field notes of his investigations. These notes would one day find their way into his *Canadian Arctic Recollections*, a book as captivating as the Arctic explorers' journals he had so admired in his youth. At other times, he marvelled at the spectacular beauty of the coast. Sometimes he would be witness to giant icebergs splitting asunder to the accompaniment of thunderous roars and massive tidal waves. In more peaceful times, the stately structures would seem to be parading majestically through the silent sea. Once, Soper saw a great iceberg with a graceful archway set against the horizon; in the foreground, a solitary polar bear contemplated his hunt close at hand.

A spell of mild weather in September proved to be a joyful time for all. Soper joined his Inuit friends as they celebrated the pleasant days with boating parties, seal hunts, and berry-picking excursions. One afternoon, the RCMP invited Soper and his companions, Constable Tredgold and Corporal Fielder, to the far end of Pangnirtung Fiord, a magnificent haven of lofty mountains and gigantic glaciers. There they left their boat and walked north for miles. They traversed a long alluvial plain extending several miles from the sea and made notes on the many branches of the turbulent Weasel River.

AT LEFT : A POLAR BEAR AND A LARGE ICEBERG, SCULPTED BY WAVES AND THE SUN, OBSERVED NEAR THE ENTRANCE TO CUMBERLAND SOUND, BAFFIN ISLAND.

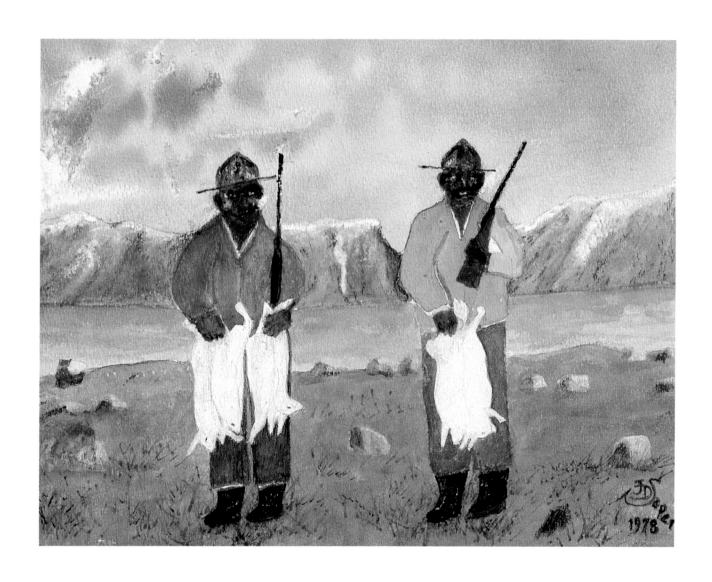

Corporal Fielder and Constable Tredgold back from a hunt in Upper Pangnirtung Fiord with six Arctic hares. September, 1924.

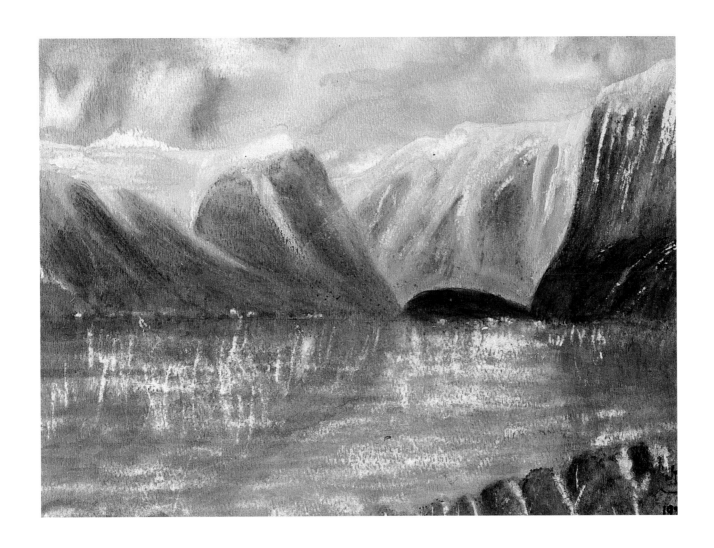

PANGNIRTUNG FIORD.

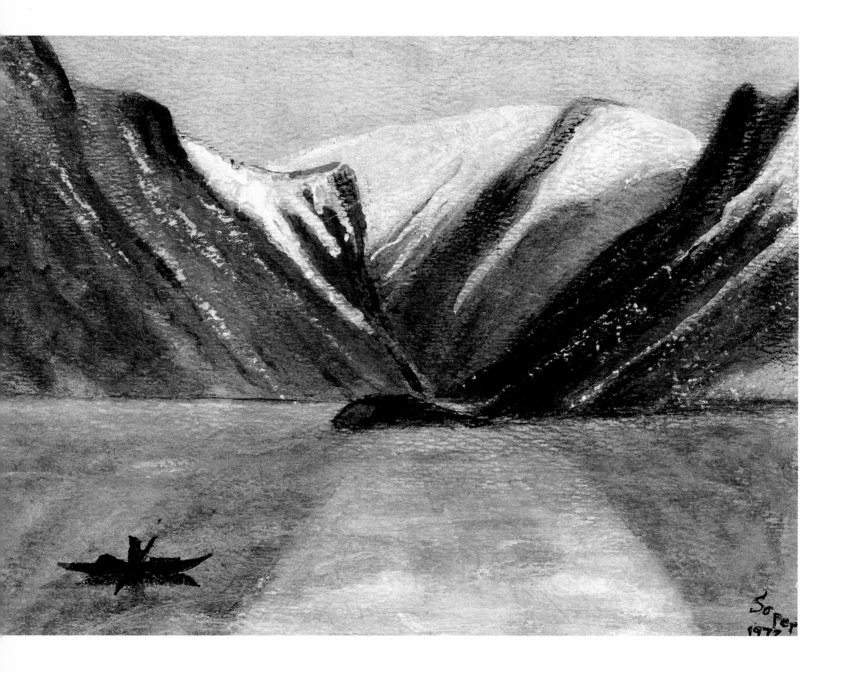

46

A few miles into the plain, Soper and his companions found Arctic hares everywhere, glaringly white against the backdrop of brown hillsides. The animals were easy to approach, for they were totally unafraid and tame. Dreaming of delectable mulligan stew — their favourite dish next to caribou meat — the party began their hunt. But they stopped within a short time, for they had secured more animals in an hour than in the whole summer.

Soon snow was on its way, and the raging gales sometimes kept Soper inside for days. But Soper kept himself busy. In anticipation of his expedition to Nettilling Lake in the spring, he requested supplies

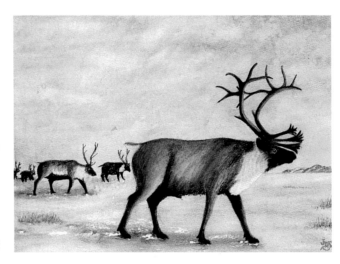

BARREN GROUNDS CARIBOU IN EARLY WINTER ON THE GREAT PLAINS OF THE KOUKDJUAK IN WESTERN BAFFIN ISLAND.

from the Hudson's Bay Company before the close of navigation that winter. Through the weeks leading to Christmas, Soper arranged for provisions to be delivered, gathered and stored.

Hunting was plentiful. Herds of caribou were heading for the highlands, and Soper accompanied Akatuga on many exciting hunts. By November, Unga had completed an entire outfit of winter clothes for Soper, and also a similar set for her husband. But the falling temperatures, averaging minus 20° F for days, began to make extended travel particularly unsafe. The winds and tides would keep the water from freezing until well into January.

Even as winter strengthened its grip over the land, Soper refused to sit idly inside. He placed great value in hiking to keep himself in top physical condition. It didn't matter which winter side-trip he planned, the whereabouts of the nesting grounds of the blue goose continued to be first and foremost in his mind. He suspected, and rightly so, that the knowledge of the Inuit would probably hold the key to the mystery. Hearing from them

AT LEFT : UPPER PANGNIRTUNG FIORD VIEWED FROM PANGNIRTUNG POST LOOKING TOWARD AULATSIVIKJUAK POINT. BEYOND, THE FIORD ANGLES NORTH, 14 MILES TO THE WEASEL RIVER.

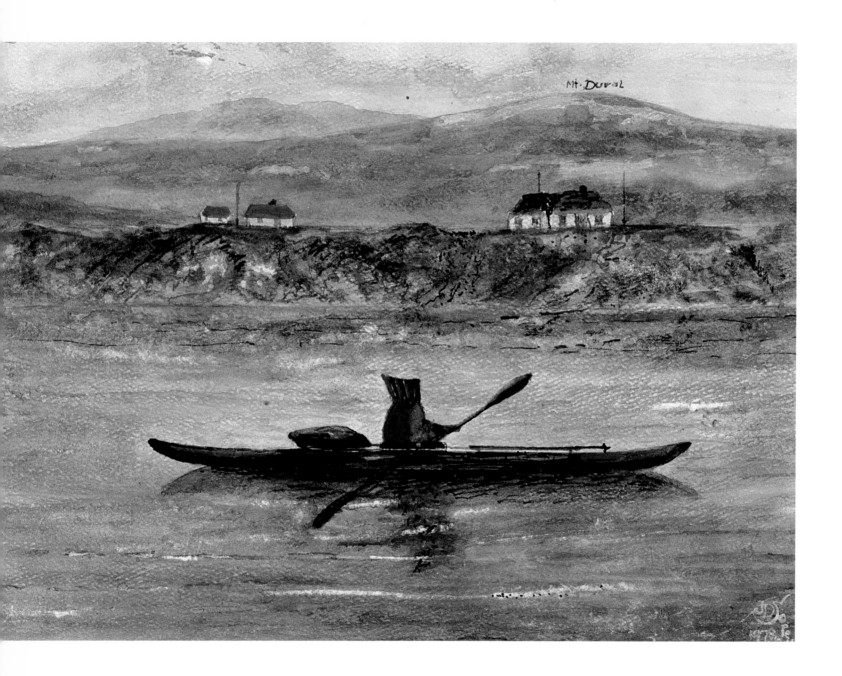

Mt. Duval

48

about an unsurveyed lake north of Nettilling Lake, Soper quietly planned a scheme to cross Baffin Island to the northwest once the conditions were right. He knew full well that he needed supply caches along the way if he were to attempt such a winter journey into the interior.

Earlier in the fall, Soper had himself investigated a section of the northwest route to the Nettilling Lake area. Shortly after Christmas, he sent Akatuga with an advance load of dog food to a site in this area. Akatuga's destination was Shilmilik (Sirmilling) Bay. Situated on Issortukdjuak Fiord just four miles north of the Arctic Circle, Shilmilik Bay was the 1882 site of the German station for the First International Polar Year. Bernhard Hantzsch had also camped here in 1910, and the ruins of both camps were still visible.

Once Akatuga returned with reports of fair conditions along the way, the two hurriedly mapped out the trip. They set out on January 6 under the light of a full moon. The clear days, however, brought a riot of colours to the midwinter sky. Sometimes the purple, studded with sparkling stars, merged with blue and black, while brilliant red and yellow enshrined the low sun.

Soper and Akatuga reached Shilmilik Bay with relative ease. But conditions deteriorated soon afterwards. As they tried to continue northwest towards Nettilling Lake, they were stopped in an impassable canyon bordered by high ridges. Frustrated, they decided to head back home. They faced temperatures as low as minus 48° F., the lowest for Soper up until this time. Soper suffered severe frostbite, and learned from the experience to insist on double caribou mittens in the future. He needed to keep his hands warm enough to be able to place them on his face and draw out the patches of frost.

The round trip from Pangnirtung took 20 days and 400 miles of travel. Although Soper failed to reach his destination, the time was well spent in learning from his Inuit companion valuable lessons in Arctic survival.

Disappointed in his attempt to reach Nettilling Lake, Soper was back in Pangnirtung earlier than he had anticipated. With time on his hands, he decided to attempt a crossing of the two great mountain passes of Pangnirtung and Kingnait, a challenge he had first thought of during his trip to Cumberland Sound in 1923.

AT LEFT : AN INUIT KAYAK OFF PANGNIRTUNG POST.

Although the Vikings had probably been there centuries earlier, the Europeans first learned about

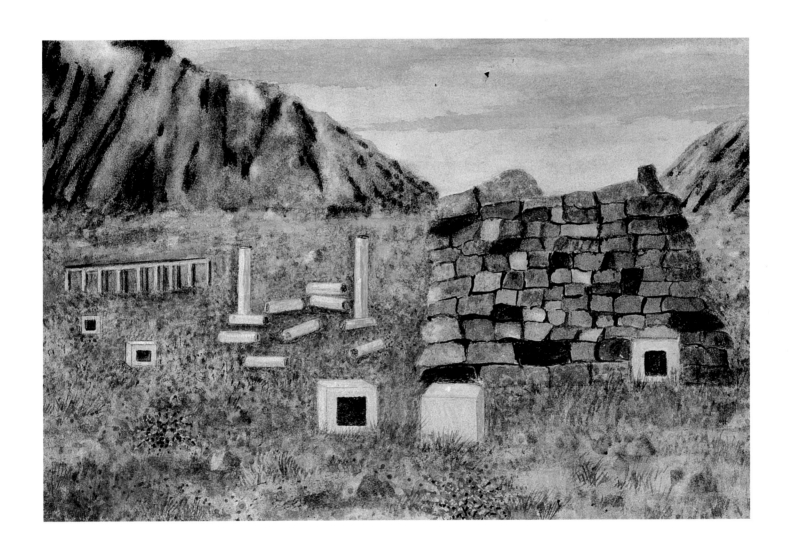

RUINS OF THE GERMAN SCIENTIFIC STATION ESTABLISHED IN 1882 AT SHILMILIK (SIRMILLING) BAY, ISSORTUKDJUAK FIORD, 4 MILES ABOVE THE ARCTIC CIRCLE.

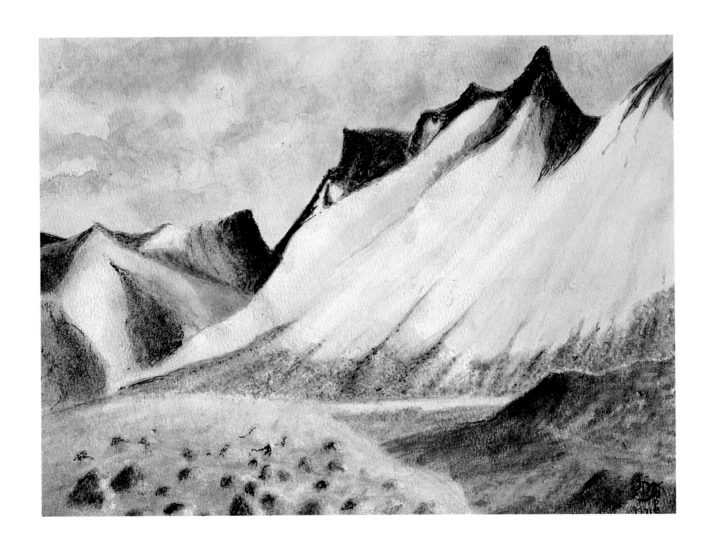

MT. ODIN, PANGNIRTUNG PASS. A TRACK SURVEY WAS RUN THROUGH THE PASS IN EARLY FEBRUARY, 1925.

southern Baffin Island from Martin Frobisher in 1576. During the nineteenth century, explorers like John Ross, William Parry, John Rae and others touched the Baffin shores. But Soper was the first white man to survey the pass and the cordillera (a main mountain axis) of the Pangnirtung sector. Soper considered these mountain ranges the most spellbinding in the Canadian Arctic. This was the area that later became Canada's first Arctic national park. It was given the Inuit name, Auyuittuq, meaning "a land where little high-altitude melting ever takes place".

Soper planned the trip with meticulous care. He hunted seals, then froze, chopped and bagged them for dog food. He prepared large quantities of pre-cooked stew for himself, frozen in small cubes from a mixture — which he found quite appetizing — of smoked buffalo pemmican, white beans, dessicated potatoes, bacon, butter and seasoning.

But the ascent over Pangnirtung Pass was quite harrowing at times. The first part of the journey would have been impossible without the additional help of an Inuit named Kilabuk and his team of twelve dogs. Some of the ridges they faced were so challenging as to render the dogs powerless. The sledges would then have to be hauled up the slopes with lash ropes. At other times, the squalls were so powerful they would bowl the dogs over completely, while they struggled, with mournful howls, to keep on an even keel.

They passed through scenes of wild grandeur — glaciers moving through ice-polished and striated granite walls of spectacular valleys, and magnificent mountains rising on both sides to heights of 3,000 to 5,000 feet.

Soper's return to Pangnirtung was through the Kingnait Pass, a less spectacular route preferred by the Inuit. At Kekertukdjuak, Broughton Island, he had to find replacements for two dogs which had contracted *pibloktuk*, a kind of distemper, and had to be shot. He purchased two dogs at the native village at a price of $10.00 each, paid for in ammunition and tobacco.

Back in Pangnirtung, Soper devoted his time to writing a report of his trip using his field notes on the wildlife, geology, weather, and surveys. Much time was also spent in preserving the many specimens collected on the way.

Soon, it was time to concentrate once again on the expedition to Nettilling Lake. Supplies had to be gathered, caches set up at depots, dogs trained, and survival techniques mastered. There was much excitement

AT RIGHT – LOWERING A LOADED SLEDGE WITH LINES AT *The Barrier*, KINGNAIT PASS, WHERE A 200 FOOT DESCENT OCCURS A SHORT DISTANCE SOUTH OF ISLAND LAKE

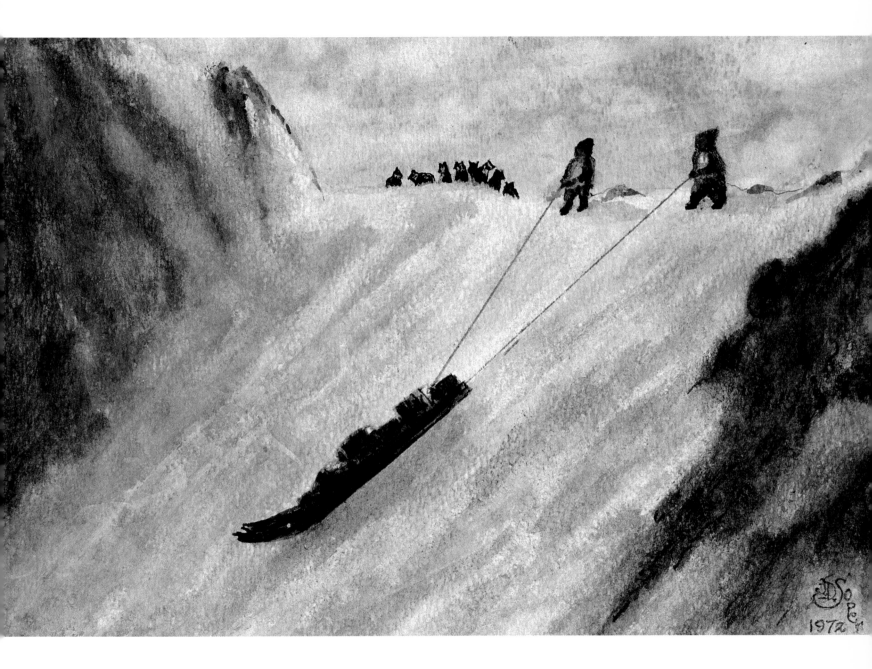

and anticipation as the lake was not known to everyone in the party, which included Constable Tredgold, Soper's assistant Akatuga and his wife Unga, as well as a second Inuit family and their child. Although additional help had been enlisted, Soper was at first reluctant to include the Inuit women. But Soper changed his mind when they proved to be as tough as the men. They were masters of sewing, cooking and camp chores, skills they willingly applied in helping Soper with his work for the museum.

It was important for Soper to reach Nettilling Fiord in March or April to be ready for the bird migrations. After all, the blue goose still remained the primary reason for the expedition. In early spring the shore ice would remain frozen to the walls, and this would permit the dog teams to travel over the solid ice past the vicious tide rips on the way to the lake. The party departed on April 22 with a complement of sixty-eight dogs and additional people for the outgoing portion of the journey.

On a sunny May 5th, 1925, Soper and his party reached Nettilling Lake, a great body of water known only to a few white men such as Bernhard Hantzsch. They had travelled over dangerous patches of open water and melting ice in traversing five lakes. The land had once been a favourite summer hunting ground. As a result, all around them were remains of ancient Inuit camps and cairns. Here they camped, blocking the tent with as much snow as possible for insulation.

AT RIGHT : SOPER EXPEDITION GROUP AT NETTILLING LAKE DURING THE SUMMER OF 1925. THE PARTY IS FOR A 'MUG-UP'; THE FIRE HAS BEEN STOKED WITH HEAVY, SMOKE-PRODUCING *keokta* (WHITE HEATHER).

BURWASH BAY, NETTILLING LAKE.

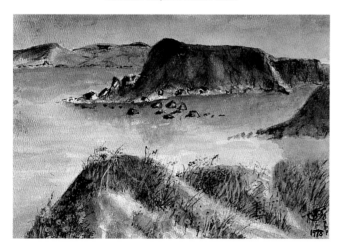

By late May and early June the bird life was plentiful. Restless flocks of snow and blue geese wheeled over the still frozen Nettilling Lake. Unfortunately, to Soper's great disappointment, they did not nest.

But there was other wildlife: caribou in increasing numbers, wolves, arctic fox, and varieties of birds suchs as horned larks, purple sandpipers, gulls, loons

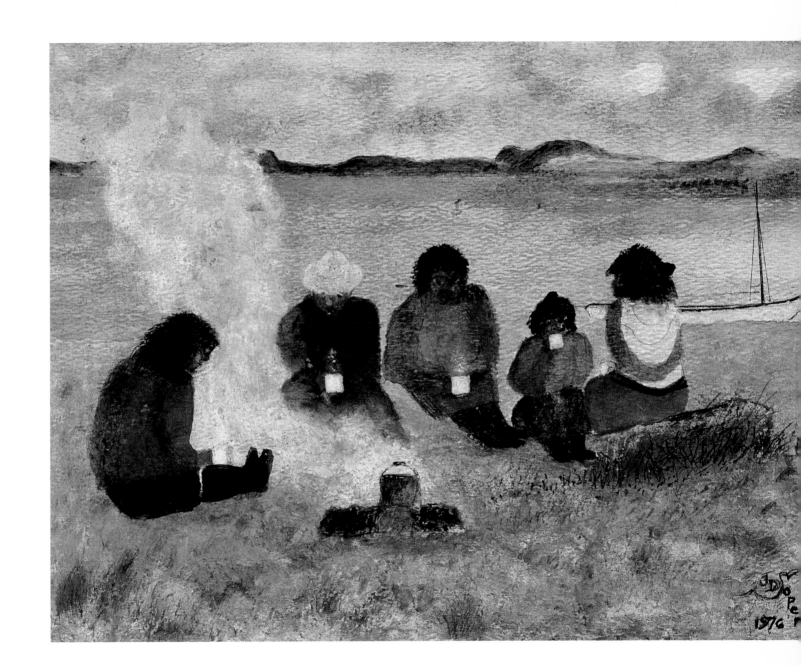

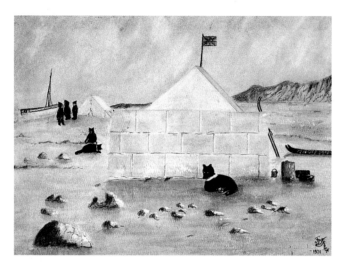

CAMP OF SOPER AND HIS PARTY AT ISOA, EAST END OF NETTILLING LAKE, MAY, 1925. THE SNOW BLOCKS AROUND THE TENT DEFLECT THE WIND.

and ducks. Soper was content to spend his time collecting specimens and preparing them for preservation. Finally, as arranged, Soper and his party were picked up at Nettilling Lake on September 20 and taken back to Pangnirtung by the R.C.M.P. in their boat, the *Lady Borden*. The ship was a week late in coming, and it proved to be a terrible time of continuous gales when the party was forced to stay in sleeping bags most of the time to keep warm .

Adding to Soper's disappointment with the blue geese was the death of Unga, Akatuga's wife, during their absence. Soper watched with sadness as Unga was buried under a canopy of angular rocks near her village.

There were two treks in the winter of 1926, one returning to Nettilling Lake and Foxe Basin on the west coast of Baffin Island. This was the area where the German naturalist Bernhard Hantzsch had died in the summer of 1911. The other was a longer journey to Cape Dorset on the Foxe Peninsula to examine the fauna, flora, and physical geography.

The weather in May of that year was miserable — wet and cold with sleet. It grew warmer in June and Soper observed hundreds of snow and blue geese migrating northeast over the Dorset Mountains. He felt he was getting closer to the end of his search. Soon afterwards he met an old Inuit hunter from the Tikoot Islands who claimed that the blue goose nested along the Foxe Basin coast near Bowman Bay. Soper was full of excitement over this piece of intelligence. The old man was definite and other natives supported his claim.

By now it was too late in the summer to journey to the Bowman Bay area. It was also the end of his term in the north. Soper therefore returned to Ottawa hoping to convince the government to let him return to Baffin Island the following year. He would have to wait.

AT RIGHT : A CONSPICUOUS CAIRN, *inuksuk*, BUILT AS A DIRECTION MARKER ON THE EASTERN SHORE OF NETTILLING LAKE.

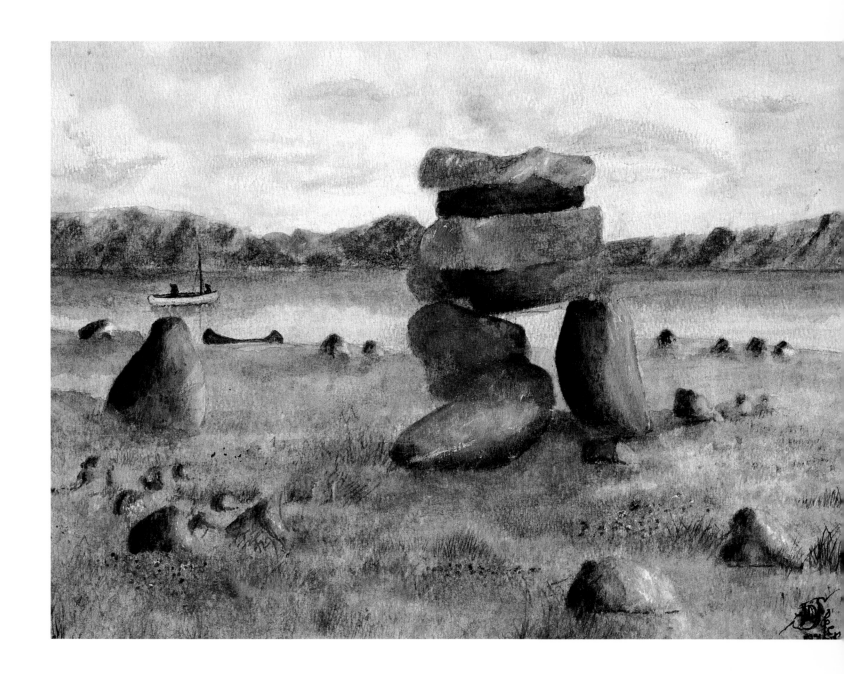

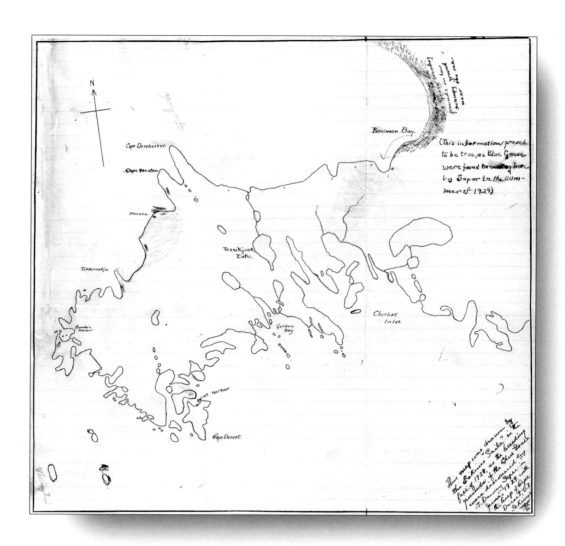

N

Cape Dorchester.

Cape Weston.

Nuwata.

Bowman Bay.

(This information proved to be true, as Blue Geese were found breeding here by Soper in the summer of 1929)

Tessikjuak Lake.

Tirkirvakju.

Cherbak Inlet.

Gordon Harbour.

Gordon Bay.

Dorset Harbour.

Cape Dorset.

This map was drawn by the Eskimo "Saila" in the fall of 1928, as the breeding grounds of the Blue Goose was first secured by J. Dewey Soper in January, 1929 with the help of Saila, the chief Eskimo of Dorset, & Eskimos.

THE MAP OF FOXE LAND DRAWN FOR SOPER BY SAILA OF NUWATA IN 1929.

Part 3 — 1928-1929

\mathcal{A}fter an initial period of uncertainty marked by a certain reluctance on the part of the government, Soper finally received permission to return to the North in 1928. In May of that year, Soper arrived at his new base on the west coast of Baffin Island. At Cape Dorset, his new home, Soper met an Inuk named Saila, who drew him a map of the blue goose territory exactly as described by the hunter from the Tikoot Islands. It was well past the summer migration for the year, too late to follow up on Saila's map. Instead, Soper used the months that lay ahead for other expeditions.

This time Soper found himself a new assistant, Shappa, an experienced caribou hunter who knew the interior quite well. Together, they organized their first journey by boat along the Foxe Channel coast to Cape Dorchester. They set out in good weather on a calm sea that was soon whipped into fury by high treacherous waves. Seeking shelter, they took their boat into Bowdoin Harbour and camped for a day amidst thick fog and gales. Later, a break in the weather permitted them to sail to Nuwata. Here, they were greeted by a group of men, women and children, members of the only tribe living on this uninhabited and little known coast. Soper observed from their sealskin *tupiks* that conditions were harsh and poor in this isolated community. Canvas tents which did not require the labour of curing were increasingly in use in other communities, but not here.

In spite of the abundance of shorebirds, geese, and ringed seals along the coast, Soper was surprised to find the Nuwata natives living chiefly on walrus meat.

AT RIGHT : ON THE BEACH AT NUWATA, FOXE CHANNEL, BAFFIN ISLAND, DURING THE LATE SUMMER, 1928.

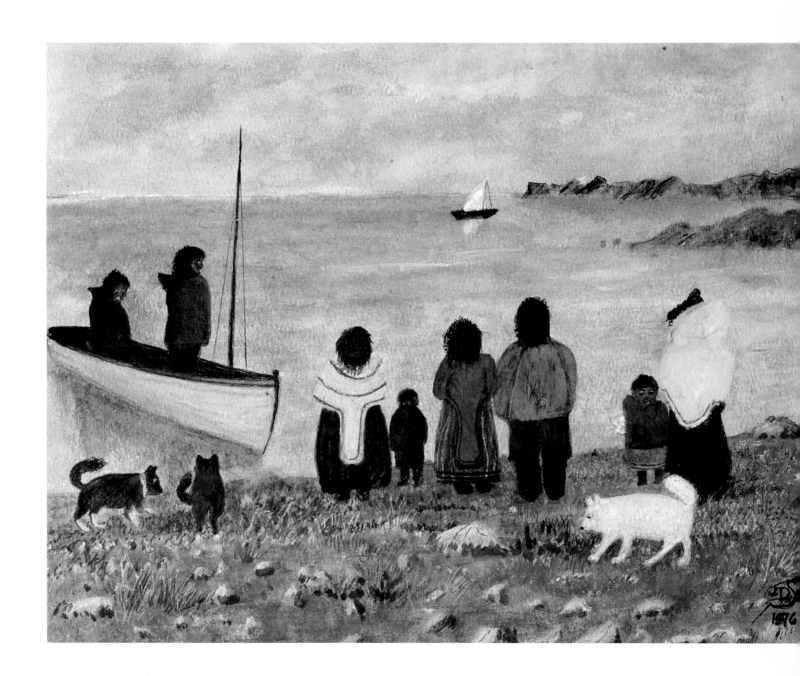

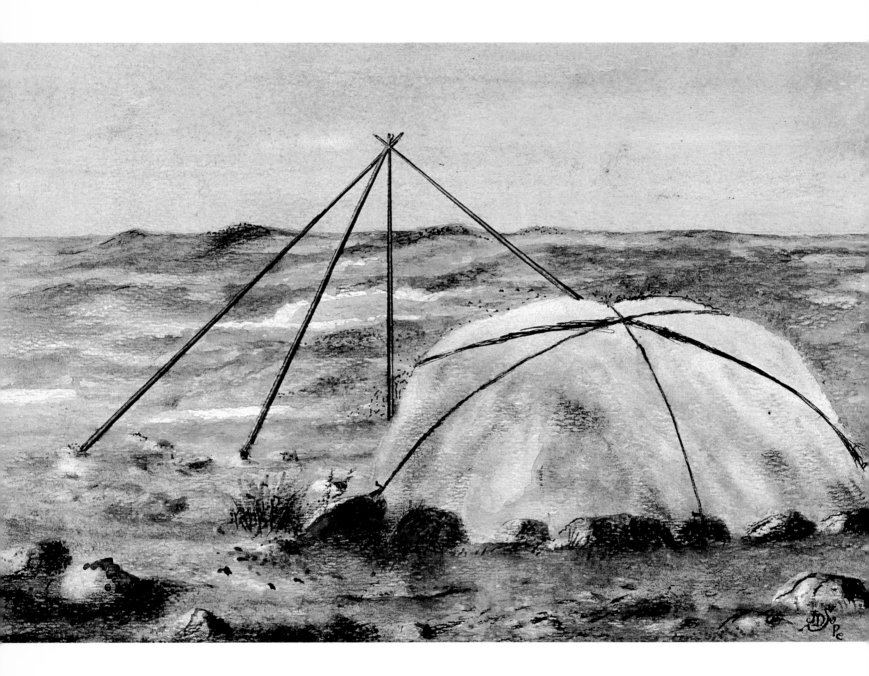

They stored the meat in piles on the tundra and covered them well with boulders to keep the meat cool and protected from foxes, wolves and polar bears.

After another delay on account of sleet, fog, and a continuous gale, they set out once again only to have a sudden wave drench and stop their outboard motor. Their canoe began to drift helplessly out to sea, their plight becoming more precarious by the minute. Fortunately, the motor roared into action just as they began to fear the worst. They finally completed their journey up the coast to Cape Dorchester and returned to Cape Dorset by the end of August. Even under these adverse conditions, Soper was pleased to have collected over 70 biological specimens. It was not without reason that the Inuit called Soper 'Kiameate', a name which Soper believed had something to do with the preservation of birds.

Preparations were soon under way for a trip into the interior of Foxe Peninsula where the Inuit claimed there were many fine lakes never before seen by white men. The weather was miserable. After many delays, Soper and his two helpers, Shappa and a fine middle-aged Inuit named Kavivow, started from Dorset on September 13th. Even though both knew the land from years of caribou hunting, it was relatively late in

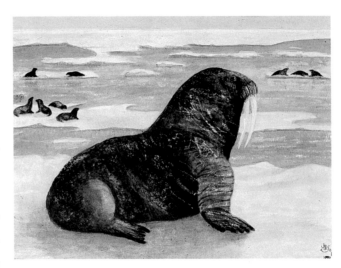

ATLANTIC WALRUS ON ICE FLOES NEAR CAPE DORCHESTER, FOXE CHANNEL. WALRUS MEAT WAS AN ESSENTIAL PART OF THE LOCAL DIET.

AT LEFT : A TEMPORARILY ABANDONED CAMPSITE AT NUWATA, FOXE CHANNEL.

SHAPPA AND KAVIVOW PORTAGING ON FOXE PENINSULA.

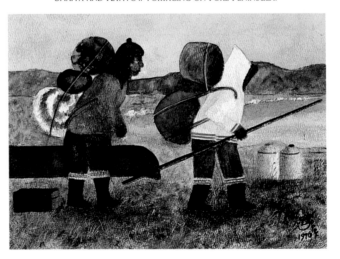

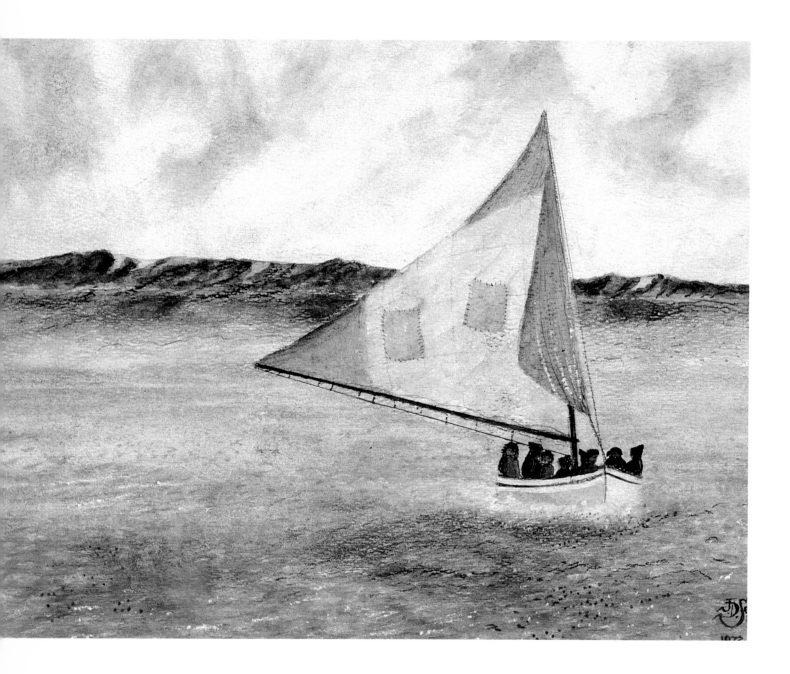

the year and Soper worried they could be caught by the freeze-up of the lakes. This would make travel by boat impossible and the ice would be too thin for sledge travel. A dangerous predicament, indeed.

The party hastened north along a route passing through a series of eight lakes and as many portages. Between them they carried a large portion of provisions and equipment to store in caches along the way, supplies they would need on next summer's return trip from Bowman Bay where they hoped to find the blue goose nesting grounds. The caches were an important precaution since Soper noted that game of all kinds was surprisingly scarce.

By this time of year the weather was becoming increasingly foul. Temperatures were severe, accompanied by violent and persistent gales. And the caribou were nowhere to be seen. Should they find themselves trapped, there would be no way to live off the land. Indeed, survival seemed far easier back on the coast.

Conditions for research were far from ideal that autumn of 1928. With little sun and cloudy night skies, not much could be done with the theodolite for magnetic declination or other measurements based on the sun and stars.

Returning to Cape Dorset in October, Soper carried out a survey of the bays, inlets and islands by boat as long as navigation was possible. He also collected more natural history specimens before the start of winter. Then it was time to return to the sedentary work of organizing his field notes into official reports.

Among the many preparations for winter was one requiring stowage of canoes. The Inuit would build an ingenious cradle to hold a canoe off the ground, at a height which would make it impossible for even the most determined dogs to reach.

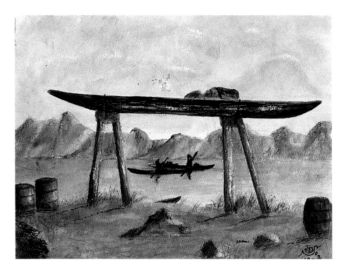

A KAYAK STORED FOR THE WINTER ON SUPPORTS
TO KEEP IT OUT OF REACH OF DOGS.

AT LEFT : INUIT SAILING A WHALE BOAT NEAR JUBILEE IS., NEAR CAPE DORSET.

THE SOPER CAMP AT TAVERNER BAY, FOXE BASIN, MARCH 1929, DURING A
SURVEY FROM CAPE DORSET TO BOWMAN BAY AND THE HANTZSCH RIVER.

AT RIGHT : SHAPPA CLEARING TANGLED DOG TRACES WHILE CROSSING
THE FOXE PENINSULA IN MARCH OF 1929.

As his work with notes neared completion, Soper began to prepare for a winter journey of exploration into an unknown area of Foxe Peninsula.

By late December sledging conditions were excellent. Soper and Shappa eagerly set out once again for the community of Nuwata. This time the journey was to be east across Andrew Gordon Bay and then northwest through the interior of the unknown Foxe Peninsula. Along the way they saw occasional *inuksuks* (Inuit rock markers) suggesting that caribou hunters had penetrated deep into this austere barren land. However, there were still no signs of caribou. This would perhaps explain why the interior was no longer sought out by the Inuit hunters.

Time and again, Soper marvelled at Shappa's care and sensitivity in the handling of the dogs and sledges. He realized what an intricate art sledging could be, especially in the hands of the experienced hunter.

In recalling his time in the North, Soper commented that the white man could always learn to play his part well in that harsh environment. But to be truly at home here, he had to be infinitely patient and follow those who had confronted the difficulties of the land for hundreds of years. In the course of his adventures, Soper came to believe that the natives of the North possessed unique talents and a mechanical genius unsurpassed by other people.

Soper's final trip before the main foray into Bowman Bay was a long journey up the west coast of Baffin Island to the Hantzsch River. This was terra incognita. With the exception of Bernhard Hantzsch's explorations in the summer and autumn of 1910 when his party reached the river by way of Nettilling Lake from Cumberland Sound, no white man had made the trek.

In February of 1929, following a route from his base in Cape Dorset, Soper and his party travelled by way of Andrew Gordon Bay across the interior of Foxe Peninsula on to Bowman Bay. On March 22, they arrived at the point on the coast north of the Koukdjuak River which Soper had reached from Pangnirtung in February 1926. After a stop at Taverner Bay, the support party returned south, while Soper and Shappa pushed northward towards the Hantzsch River.

Much of the land, especially the Foxe Peninsula, is a geographic nightmare of mountains and lakes, a rocky coast bordering an ice-glutted sea, and treacherous weather. The interior was also surprisingly devoid of wildlife. As always, the challenge excited Soper. Using Hantzsch's charts, Soper and Shappa found the late German explorer's latitudes correct, but many of the longitudes wildly inaccurate.

Such observations can be very tricky under difficult conditions. Adjusting delicate instruments with hands clad in caribou mittens, or taking them off to touch metal in an Arctic winter, could be painful and difficult. Wearing thin gloves, Soper was once so absorbed in his work that he froze his fingers. For a week, his right hand remained useless.

Exploring the isolated and lonely land around Hantzsch River, Soper hoped to find a cairn with perhaps Hantzsch's final words. He had died from trichinosis by eating raw polar bear meat. His Inuit companions, who had been fearful of the expedition because of the lack of wildlife, buried Hantzsch under a pile of rocks and returned to Cumberland Sound with his journal and records. This material became the basis of Soper's own expeditions.

Returning from the trip to the Hantzsch River in April of 1929, Soper hurried into preparations for the long-awaited blue goose expedition. His journals recall how his excitement mounted as the day of the expedition's

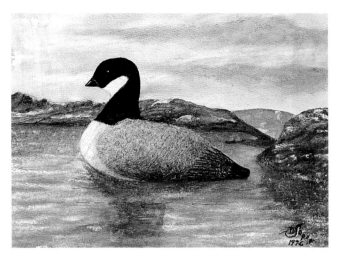

HUTCHINS' GOOSE, MID-SUMMER OF 1929 AT BOWMAN BAY, WESTERN BAFFIN ISLAND.

AT LEFT : THE SCIENTIFIC CAMP AND GEOGRAPHICAL CAIRN AT THE BLUE GOOSE RIVER, NEAR FOXE BASIN. THE BLUE GOOSE NESTING LOWLANDS ARE IN THE DISTANCE.

departure drew closer. Soper was determined to pitch his camp before the geese arrived so as to learn as much as possible about the spring migration.

Mid-May was the target for setting out for Bowman Bay, to the site the Inuit had repeatedly urged Soper to visit. He set out on May 17th, accompanied by five Inuit helpers, four heavy sledges, and a team of forty-two dogs. The party reached Bowman Bay on the Great Plain of the Koukdjuak on May 24th. They pitched their tent near the banks of a stream chosen by the Inuit, which they named the Blue Goose River. The site they named Camp Kungovik (blue goose). The latitude was 65° 35' N.

Here there was time for Soper to reflect upon unseen bonds with travellers from earlier times. Close to their campsite, they found a ring of rocks from an old Inuit campsite. It suggested a time when the wildlife must have been far more abundant than the nearly lifeless land that they now found.

Soper appears to have discovered a profound feeling of contentment and isolation. Perhaps it was a moment of tranquil anticipation, to be followed by the thrilling realization that his years of dedication were somehow poised on the brink of fulfillment.

Seasoned explorer that he was, Soper must have known there would still be stormy days ahead. By early June the snow began melting quickly. The mild weather alternated with raging gales and more snow. Not until the end of June was the Blue Goose River in full flood and the region free of snow.

June 2 brought Soper the moment he had been waiting for. A honking flock of snow and blue geese flew over the camp, observing the land below. But they did not stay. Instead, freezing weather returned and snow drifts two and three feet high piled up around the tents. Then, a few days later, flock after flock winged into the area. This time, large numbers stayed behind. For Soper and his party the great moment had arrived — the shroud of mystery surrounding the blue goose was about to be lifted on the shores of Bowman Bay.

On June 14 and 15 clamouring hosts of birds

AT RIGHT : BLUE GEESE ON THEIR BREEDING GROUNDS AT BOWMAN BAY, WESTERN BAFFIN ISLAND IN THE SUMMER OF THEIR DISCOVERY BY J.D. SOPER IN 1929. IN JUNE OF THAT YEAR, WITH THE HELP OF INUIT COMPANIONS, HIS LONG DEDICATION TO SOLVING THE MYSTERY OF THE BLUE GOOSE WAS FINALLY REWARDED. OVER THE COURSE OF THE MONTH HE WITNESSED THE ARRIVAL OF THE FLOCKS AND OBSERVED NESTS OF EGGS AND THE HATCHING OF GOSLINGS.

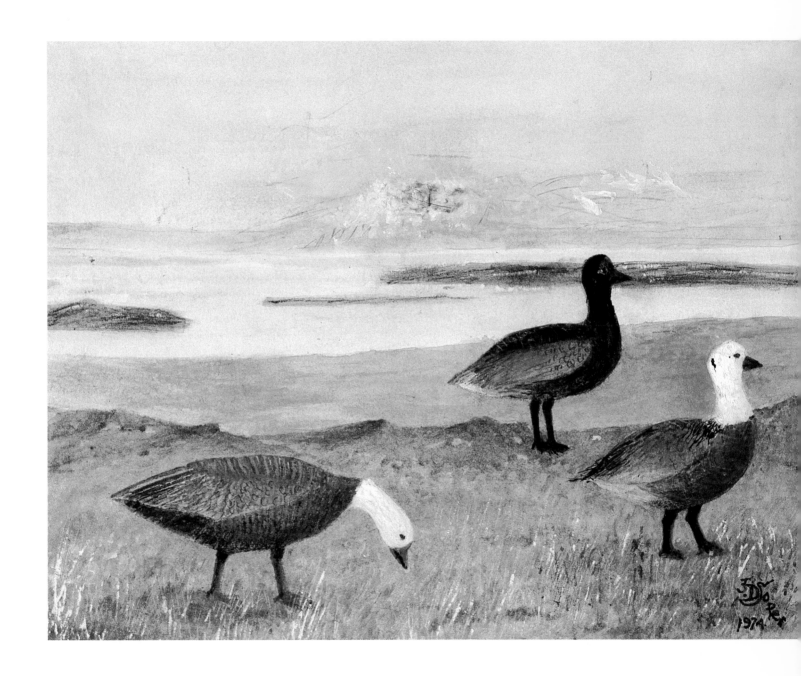

filled the air with their primeval cries. Their sound brought to Soper's mind Allan Parkinson's poem on migrating geese:

>*the wild, weird honking clamour*
> *of the wild geese in their flight.*
> *And ever at the thought I feel a subtle*
> *inward thrill —*
> *A word-defying something — you may*
> *call what you will.*

On June 20, Soper discovered the first blue goose nest containing a single egg. Each day thereafter, he came upon many new nests. There was little doubt that Soper had indeed found the nesting grounds of the Blue Goose.

July 20 was something of a red-letter day as Soper witnessed the hatching of the first gosling. The summer daylight gave Soper ample time to make a sizeable collection of birds, eggs and other ornithological data. He also went about collecting specimens of the luxuriant vegetation that now painted the ground in gorgeous shades of purple and red — saxifrages, poppy and white mountain avens.

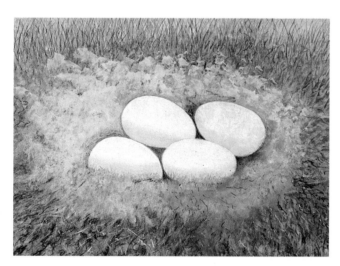

ONE OF THE FIRST NESTS AND EGGS OF THE BLUE GOOSE KNOWN TO SCIENCE, JULY 4, 1929, NEAR CAMP KUNGOVIK, BLUE GOOSE RIVER, FOXE BASIN, BAFFIN ISLAND.

There were birds everywhere, not only geese, but sandpipers, jaegers, Sabine's gulls, snow buntings, Lapland longspurs and horned larks. Here was a summer teeming with wildlife and vegetation, a dramatic reversal from the lifeless depths of winter. Time had moved from the polar panormama of far-reaching desolation to a resurrection of miraculous glory.

After about a month, Soper felt his work had been done. The party left Camp Kungovik on July 20 hoping that the Foxe Basin would be sufficiently free of ice to allow travel to the Kommanik River. They planned a route overland to the chain of interior lakes leading to Andrew Gordon Bay — another area unexplored by white men. To their disappointment, huge fields of pack ice almost prevented them from escaping Bowman Bay.

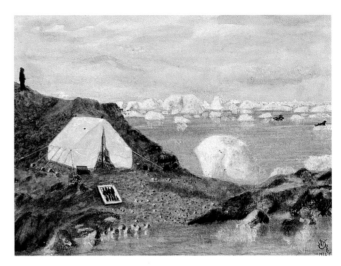

THE SOPER CAMP AT CAPE ALBERTA.
HEAVY PACK ICE PREVENTED TRAVEL FOR SEVERAL DAYS. LATE JULY, 1929.

On the morning of August 3, Soper and his men finally found a way out of their predicament. They broke free from the ice and settled on the sea floor at a time when the tide was out. They were two miles away from land. All around them were massive pieces of old ice with a thickness of six to twelve feet. They slept fitfully in their canoes, ever watchful of the next tide.

With great difficulty, Soper and his men eventually maneuvered their canoes south to Farley Point. There were further delays before they managed to reach Cape Alberta. Here, massive ice boulders pushed them onto the rocks. Trapped for nine days, their situation raised some real concern about their ability to extricate themselves from the ice. Soper himself was unconcerned. He passed the time taking measurements on the seafloor of Foxe Basin.

The caches of food and provisions from the autumn before were a welcome sight. But when they reached Andrew Gordon Bay on August 16, they found that they had missed the SS *Nascopie* by two weeks. Soper hurriedly made arrangments to charter a boat from his Inuit friends.

They set out again, this time for Lake Harbour, two hundred sixty miles away. Fighting fierce easterly winds, they reached their destination on August 24, just nine hours before the arrival of the SS *Beothic*.

Soon after boarding the ship, news of the success of the Blue Goose Expedition was broadcast on the international wires. A week later, J. Dewey Soper returned to Ottawa. He had finally solved the mystery of the blue goose.

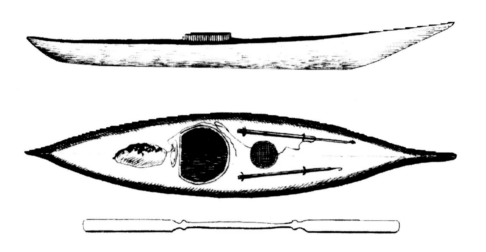

Part 4 — 1930-1931

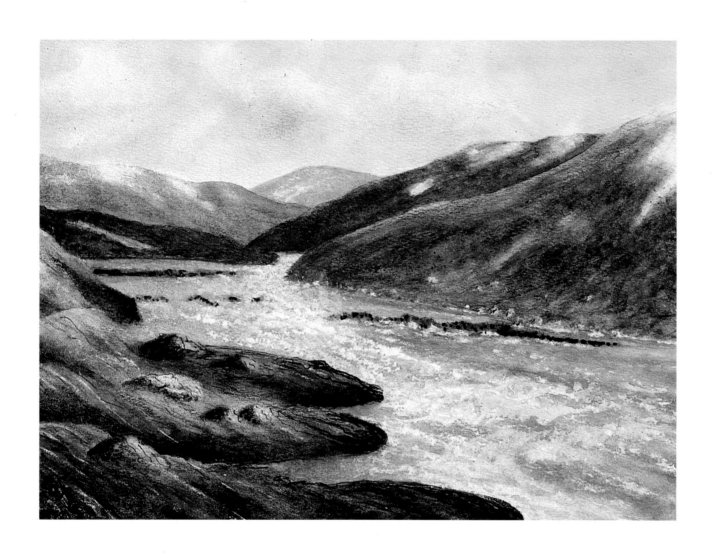

RAPIDS ON THE UPPER SOPER RIVER NEAR ITS MOUTH AT THE NORTH END OF SOPER LAKE, A SHORT DISTANCE FROM LAKE HARBOUR. JUNE 1931.

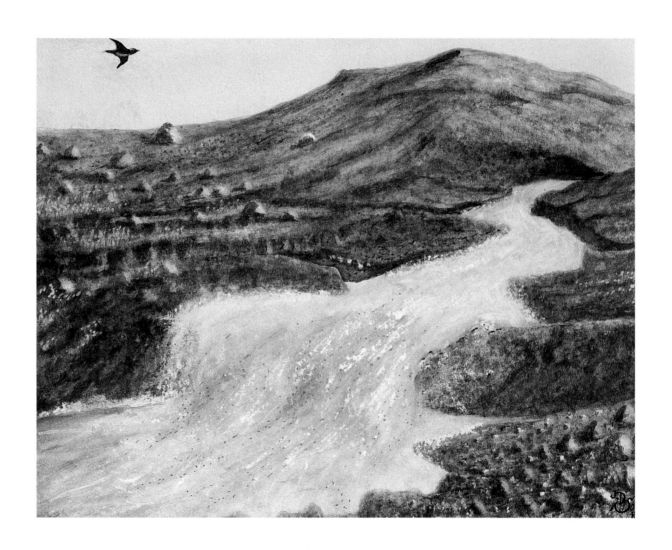

WATERFALLS AND RAPIDS ON THE LOWER CASCADE RIVER, A TRIBUTARY OF THE SOPER RIVER. JULY 1931.

*T*he lure of the North and his relentless search for the whereabouts of the blue goose remained the highlight of Soper's career. During seven years since 1923, he had conducted many journeys over the unmapped territory of southern Baffin Island. In the process, he had travelled 30,000 Arctic miles. His had been a major contribution to the fields of geography, ornithology, and to the knowledge of the North in general.

As a token of the government's appreciation of his contribution, Soper was given another one-year assignment on Baffin Island. This time his base was to be the R.C.M.P. post at Lake Harbour. Soper's task was to explore the inlets and bays in that area along the north side of Hudson Strait. This area, consisting of such places as White Strait, McKellar Bay, Shaftesbury Inlet and the rivers running to the north, had never been surveyed in detail. Though well mapped today, but perhaps as a testimony to its remoteness, the area is still called Meta Incognita Peninsula.

On this expedition, Soper would enjoy the added pleasure of being able to take along his wife Carolyn and their two-year-old son Roland. Soper busied himself immediately. Soon after their arrival at Lake Harbour, he went to work with his Inuit assistants and built his family a comfortable house.

It was not to be a long idle winter for his wife either. She had trained as a nurse and, being the only one in the area with medical knowledge, she began to care for both the Inuit and white people. But her most serious challenge was a tragic epidemic of respiratory polio that attacked the native community. On this occasion, Carolyn found herself helpless to prevent loss of life.

Years later, Carolyn described the trauma in the Hudson's Bay Company magazine, *The Beaver*:

Shortly after the Nascopie left there was a tragic period when a deadly sickness broke out among the Eskimos. I tried hard to diagnose and treat it but soon felt utterly helpless. The symptoms were a sore throat and difficult swallowing, with very little rise in temperature. The onset was sudden with death occurring in about two days. After the first two sudden deaths the Eskimos became panickly and apathetic in the face of what appeared to them certain death; and all too often this was the outcome. On one sad day five wooden coffins passed along the sandy path to the little cemetery among the rocks. In spite of painstaking effort night and day, eight deaths occurred before the epidemic finally subsided; and throughout all this the best I could do was to treat the symptoms to the best of my knowledge.

The following year the ship's doctor diagnosed the outbreak as respiratory polio — the first known occurrence in the Eastern Canadian Arctic. All concerned were deeply thankful that it was not more devastating.

During autumn, the Soper family prepared for the severe weather to come. Since it was no longer practical to embark on explorations, they looked for innovative tasks. Some projects, like laying out paths marked by white stones, served the purpose of filling time. Other work was more serious, such as hunting expeditions for food. Moosa, Soper's Inuit assistant for the year, was an excellent hunter. After one long inland hunt deep into the interior of Baffin Island, he returned with several caribou which provided food for all over several weeks. His wife Neve cured caribou skins and made winter clothes for the Soper family. As a result, even two-year-old Roly was able to play comfortably outside.

It was a happy year for the little boy except for one terrifying episode. Like all two-year-olds who are able to easily slip away from even the most watchful eyes, one day Roly managed to wander farther away than he should have. When he could not be found, everyone became anxious. The Hudson's Bay men and the R.C.M.P. joined in the search. Eventually, Roly was found. He had fallen into a deep crevice along the shore's 'barrier ice'. The high vertical walls of ice had made it impossible for him to climb out. Though badly frightened, he was unharmed thanks to his clothing which provided padding and warmth. Soper tells us how dangerous this accident could have been — deep crevices such as the one Roly had fallen into close up under the great pressure of high tide "like the giant jaws of a trap".

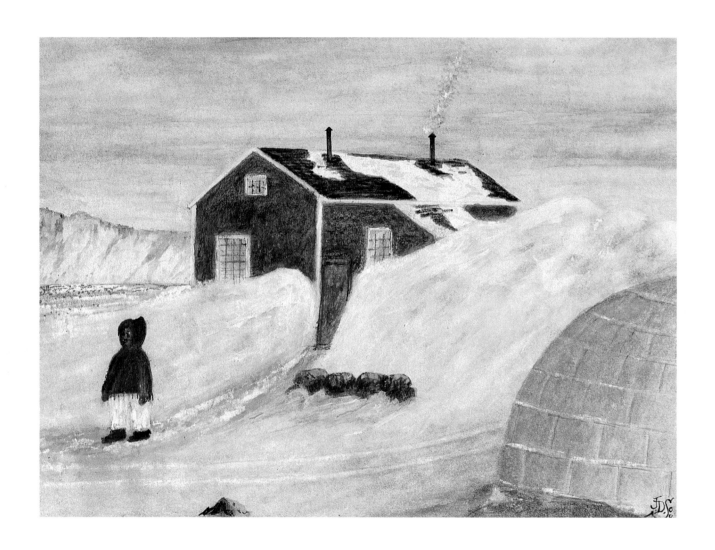

Soper residence at Lake Harbour, Baffin Island, winter of 1931. Son Roland out for a walk at age 2. assistant Moosa's igloo is on the right.

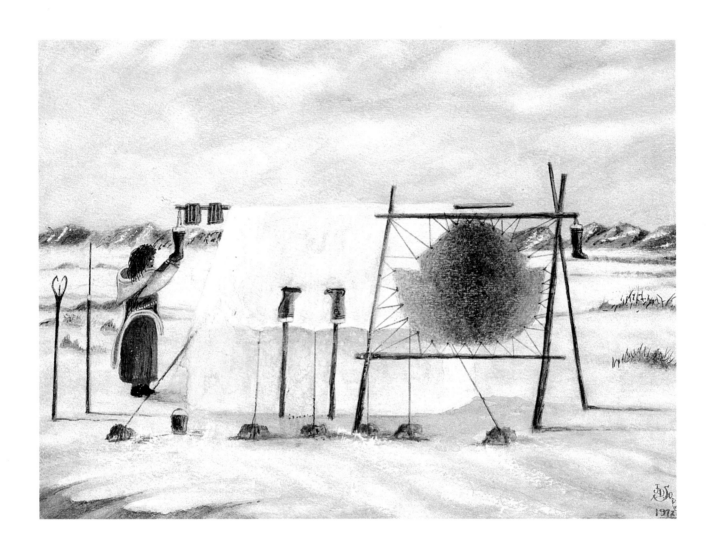

An Inuit spring camp at Lake Harbour, May, 1931. Igloos are usually abandoned by April or May in favour of a sealskin tent.

Tragedy is never far away in the Arctic and the enemy is usually the unpredictable power of the ice. Soper tells us of a local Eskimo returning from seal hunting after dark who plunged — *komatik* (sledge), dogs and all — into a wide, newly formed lead and was never seen again. A tidal current had dragged the whole outfit under the thick ice. Occasionally a hunter would be helplessly stranded and carried out to sea on a pan of ice that had broken off and floated away.

The best part of the year for all was the arrival of spring and the return of the birds. In early June, the treks began once more. As the weather became milder, Soper occasionally took along Carolyn and Roly to share the experience. By late June and into July, thanks to the long hours of sunlight, they explored up the Koukdjuak River (Big River) as well as the Cascade River, named because of its series of idyllic waterfalls.

Soper collected many specimens along the way. During the summer months he undertook reconnaissance surveys north of Lake Harbour as well as southeast to Shaftesbury Inlet. On one short sledge trip with the family to McKellar Bay in June they observed the beginning of the migration of waterfowl. It was a happy time for all with the air filled with the snow buntings' lyrical melodies. Camping near an active brook they discovered abundant wildlife and were able to collect numerous specimens for the National Museum. Though spring was deeply welcomed, the warmer temperatures on the return trip caused dangerous leads to open in the ice and the force of the tides created ominous eddies and treacherous currents.

Finally, on the evening of August 1, the Soper family said a fond farewell to the North and boarded a cargo ship, the SS *Ungava*, at Lake Harbour. From there, they sailed south to Port Churchill and on by train to Ottawa.

This was to be Soper's last journey to the Arctic. But it was in fact the beginning of his brilliant career as a Canadian natural scientist. His was to be a life devoted to studying the wildlife of North America, and he scrupulously recorded his observations in over one-hundred publications. Still, no other challenge ever quite lived up to the Arctic adventures of his earlier years.

Although Soper retired from government service in 1952, he remained active in his field. Many honours came his way over the years. In recognition of Soper's accomplishments, the Government of Canada decided in 1957 to set aside 3,150 square miles from Bowman Bay to the Koukdjuak River and to call it the Dewey Soper Bird

Sanctuary. A man of wide interests and many talents, his favourite work late in life was the weaving together of his Arctic recollections both in prose and vibrant watercolours. This was to be his final and perhaps most enduring tribute to "the 'lands forlorn' [that became] ... a pleasant memory, but always intensified by a heady allurement that would never quite leave me".

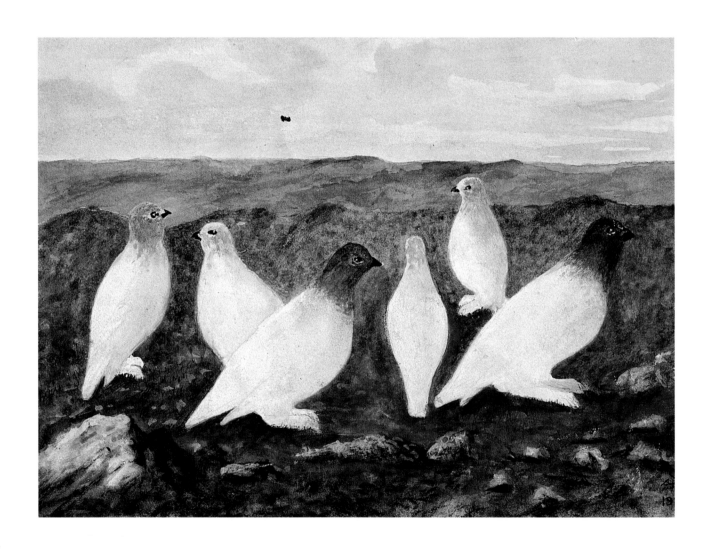

WILLOW PTARMIGAN AT THE BLUE GOOSE RIVER. THE MALES ARE DEVELOPING THE FIRST BROWN FEATHERS OF SUMMER PLUMAGE ON HEAD AND NECK.

The head of a *kukeveik* (fish spear) used for catching Arctic char.

Postscript

*U*p until 1929 the breeding grounds of the blue goose remained "one of the leading enigmas of North American ornithology". Stimulated by Soper's research and observation, knowledge has greatly advanced since then. Today we know that the blue goose is a phase of the snow goose, not a separate species. It is a species that has steadily increased in population. With this growth in numbers, the geese have selected many other nesting sites, expanding from Baffin Island into several other areas of the Arctic.

Towards the end of his life, J. Dewey Soper relived his northern experiences by writing Canadian Arctic Recollections and painting over 200 watercolours from his hundreds of Arctic photographs. His poetic prose and the bold colour of his images reveal to us the depth of his feeling for the far North. They also seem to be his way of revisiting the Arctic, thus completing the circle of his life.

A further note of interest, is Soper's way of expressing his Arctic memories. Since Soper was a highly professional natural scientist who kept meticulous records, it is something of a puzzle why his watercolours do not appear to have been rendered in any particular order. Maybe their inspiration came from his imagination rather than some objective reality and sequence captured by his scientific intellect.

His work after 1931 included wildlife surveys in Wood Buffalo National Park. In 1934 Soper was also appointed Chief Federal Wildlife Officer for the Prairie Provinces. He moved to Edmonton, Alberta, in 1948 where he was to live for the rest of his life.

Soper proudly tells us in his unpublished autobiography that, between 1915 and 1969, he collected 98,853 scientific specimens of mammals, birds and eggs which he deposited mainly in the National Museum of Canada. Many honours came his way, including a L.L.D. from the University of Alberta.

Selected Bibliography

Amundsen, Roald. *The North West Passage: Being the Record of a Voyage of Exploration of the Ship 'Gjoa', 1903 – 1907.* New York: Dutton, 1908.

Bunyan, Ian; Calder, Jennie; Idiens, Dale; Wilson, Bryce. *No Ordinary Journey: John Rae, Arctic Explorer 1813-1893.* Edinburgh: National Museums of Scotland; Montreal: McGill-Queen's University Press, 1993.

Franklin, John. *Narrative of a Journey to the Shores of the Polar Sea in the Years 1819, 20, 21, and 22.* London: John Murray, 1823. Reprint: Edmonton: Hurtig, 1969.

Hall, Charles Francis. *Life with the Esquimaux,* London: S. Low, Son & Marston, 1865. Reprint: Edmonton: Hurtig, 1970.

Hantzsch, B.A. *My Life Among the Eskimos: The Baffinland Journeys in the Years 1909 to 1911.* Translated and edited by L. H. Neatby. Saskatoon: University of Saskatchewan, 1977.

Kane, Elisha Kent. *Arctic Explorations: The Second Grinnell Expedition in Search of Sir John Franklin, 1853, '54, '55.* Philadelphia: Childs & Peterson, 1856.

Loomis, Chauncey. *Weird and Tragic Shores.* New York: Knopf, 1971. Reprint: Lincoln: University of Nebraska, 1991.

– – – – – – –. "The Arctic Sublime". In: Knoepflmacher, U.C., and Tennyson, G.B. eds. *Nature and the Victorian Imagination.* Berkeley: University of California, 1977.

Martin, Constance. "Toward No Earthly Pole: The Search for Franklin in Nineteenth Century Art". In Sutherland, P. ed. *The Franklin Era in Canadian Arctic History.* Ottawa: National Museums of Canada, 1985.

Nansen, Fridtjof. *In Northern Mists: Arctic Exploration in Early Times.* 2 vols. New York: Frederick A. Stokes, 1911.

Parry, William Edward. *Journal of a Second Voyage for the Discovery of a North-west Passage, from the Atlantic to the Pacific, Performed in the Years 1821-22-23.* London: John Murray, 1824.

Peary, Robert E. *The North Pole.* London: Hodder and Stoughton, 1910.

Rae, John. *Narrative of an Expedition to the Shores of the Arctic Sea in 1846 and 1847.* London: T.W. Boone, 1850.

Richardson, John. *Arctic Searching Expedition: A Journal of a Boat-Voyage through Rupert's Land and the Arctic Sea.* London: Longman, Brown, Green, and Longmans, 1851.

Ross, John. *Narrative of a Second Voyage in Search of a North-west Passage and a Residence in the Arctic Regions During the Years 1829, 1830, 1831, 1832, 1833.* London: O. Hodgson, 1835.

Saila of Nuwata. Native Map of Foxe Land, NWT.

Soper, J. Dewey. *Canadian Arctic Recollections: Baffin Island, 1923-1931.* Mawdsley Memoir 4, Institute for Northern Studies. Saskatoon: University of Saskatchewan, 1981.

Stefansson, Vilhjalmur. *The Friendly Arctic,* New York: Macmillan, 1921.

– – – – – – –. *Hunters of the Great North,* New York: Harcourt Brace, 1992.

Sverdrup, Otto. *New Land,* 2 vols. New York: Longmans, Green and Co., 1904.